special
effects
by
ken
biggs

PETERSEN'S PHOTO PUBLISHING GROUP

PHOTO SPECIALTY PUBLICATIONS
Brent H. Salmon/Publisher
Paul R. Farber/Editorial Director
Mike Stensvold/Editor
Jim Creason/Art Director
Lynne Anderson/Managing Editor
Charlene Megowan/Assoc. Mng. Editor

PHOTOGRAPHIC MAGAZINE
Brent H. Salmon/Publisher
Paul R. Farber/Editor
Cliff Wynne/Art Director
Jim Cornfield/Feature Editor
Mike Brenner/Technical Editor
Karen Sue Geller/Managing Editor
Joan Yarfitz/Associate Editor
Markene Kruse-Smith/Editorial Assistant
Natalie Carroll/Administrative Assistant
Kalton C. Lahue/Contributing Editor
Steve Poster/Contributing Editor
David Sutton/Contributing Editor
Parry C. Yob/Contributing Editor
Carl Yanowitz/New York Advertising Rep.
Scott McLean/Los Angeles Advertising Rep.
Dan Dent/Chicago Advertising Rep.

PETERSEN PUBLISHING COMPANY
R. E. Petersen/Chairman of the Board
F. R. Waingrow/President
Robert E. Brown/Sr. V.P., Corporate Sales
Herb Metcalf/V.P., Circulation Director
Philp E. Trimbach/V.P., Finance
Al Isaacs/Director, Graphics
Bob D'Olivo/Director, Photography
Spencer Nilson/Director, Administrative Services
William Porter/Director, Single Copy Sales
Jack Thompson/Director, Subscription Sales
James J. Krenek/Director, Purchasing
Thomas R. Beck/Director, Production
Alan C. Hahn/Director, Market Development
Maria Cox/Manager, Data Processing Services

SPECIAL EFFECTS
Project Editor/Charlene Megowan

Library of Congress Catalog Card Number/74-14433
ISBN/0-8227-0084-0

Cover
Photos by Ken Biggs;
design by Jim Creason.

special effects with film

Let's face it—the easiest technique for the beginner seeking to master special effects photography, and the one most readily available to all with no additional investment, is the creative use of film—black-and-white or color. You're going to use film anyway, so let's take a look at some of the ways and means by which you can turn the mundane into the unusual and eye-catching by your choice of emulsion and how you use it.

When you work in black-and-white, you're dependent upon contrast to create the moods and feelings you're trying to express in pictures. Normal contrast creates a normal picture, but that's not what we want to achieve here, so we bend the tonal scale to suit our needs. While there are many things you can do with low contrast, working with it is pretty tricky because the results often turn out to be dull, muddy-looking prints, so most of us turn our attention to high contrast, which adds a zip and bang to many pictures.

HIGH CONTRAST

Basically, there are two types of high-contrast pictures—those that retain some gray tones between the blacks and the whites, and those that do not. Printing a normal negative on ultrahigh-contrast paper such as Agfa's No. 6 will give you the first effect, but you can create the same effect in the camera by using Kodak High Contrast Copy film. Designed

The easiest way to create a high-contrast effect is to print a normal negative on a paper such as Agfa No. 6. This works especially well for subjects with large areas of jet black.

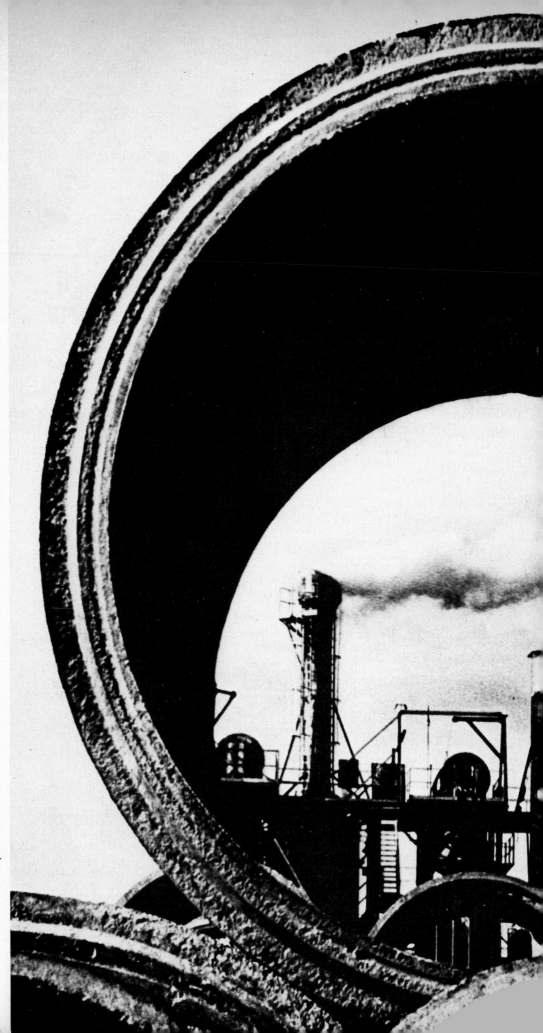

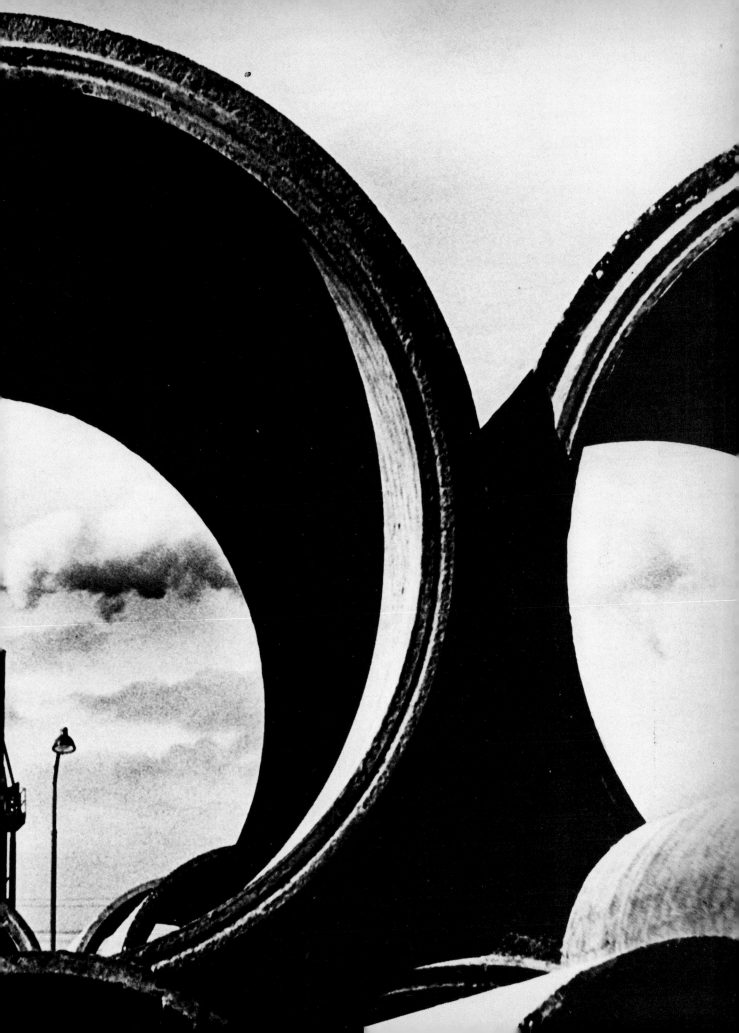

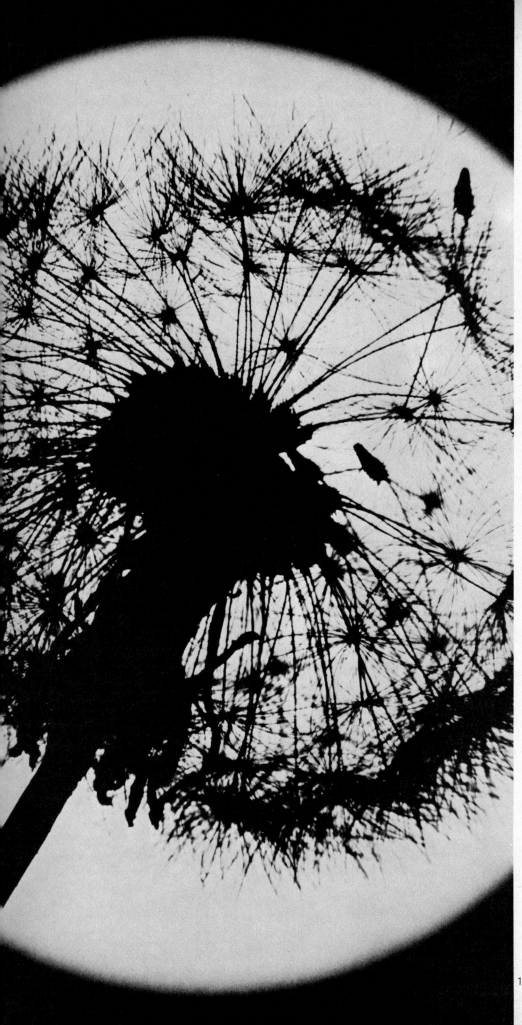

primarily for copy work under tungsten illumination, it has an effective speed of 64, but I've found that working with a rating of 25 outdoors and developing the film for six minutes in Kodak's D-19 at 68°F gives what I consider to be the ideal density. I'd suggest you use this as a departure point for your own tests, bracketing your exposures in half-stops because the film has little latitude.

When using High Contrast Copy film in the camera, you should look for subjects with backgrounds that separate in tone. If you photograph a girl in a white dress, place her against a dark background; if not, the white dress will block up on the high-contrast negative and you'll have no tonal separation in the final print. There are three easy ways to control this light/dark relationship: select the color of the subject or object to contrast with the chosen background (or vice versa), move your camera position to achieve a light-against-dark or dark-against-light relationship, and a choice of lighting. Working indoors, you can direct the amount of light necessary to achieve a maximum separation of tones; outdoors, you might take advantage of trees or a hill in the shade while the subject is lighted by the sun.

But if you're really after high contrast, why not go all the way and load up with a high-contrast ortho film like Kodalith? While many amateurs know that this emulsion is available in sheet film

1

sizes, few realize that any photo store can special order it in 100-foot rolls of 35mm, and some companies like Freestyle Photo Sales respool it for their customers in 20-exposure cartridges. Kodalith has the distinct advantage of eliminating virtually all gray tones with the initial exposure, and any that do creep by can be removed by reexposure on a second sheet of the same film.

Most photographers use their regular preferred emulsion for camera work and then enlarge the selected negatives on Kodalith instead of paper. Since the film is an ortho emulsion, you can develop it under a red safelight by inspection and control the density of the final result. The easiest way to work with Kodalith under the enlarger is to put your easel away and use a 4x5 or 8x10 film holder. Remove the slide on one side and insert a thin piece of white paper on which you can focus the projected image. The other side of the holder contains a sheet of Kodalith and after focusing your image, swing the red filter into position under the enlarging lens and turn the holder over. Compose your picture as you want it and then swing the red filter away from the lens to expose. Just as when working with enlarging paper, making a test strip is advisable at the beginning. Development time in the Kodalith A/B developer runs between 2½ and 3 minutes, then fix and wash as you would with any other film.

The result is a very contrasty positive image that requires opaquing to remove any pinholes or other unwanted details. Once this has been done, contact print the positive on another sheet of Kodalith to produce the negative, which can then be used to make your final print.

While the Kodalith process can open the door to an entirely new photographic world, you must enjoy darkroom work to take full advantage of the technique and its effects, since the process can require considerable time. The high-contrast print is the simplest of the many Kodalith processes—posterization, solarization, bas-relief, texture screens and moiré patterns (covered in full in Petersen's *Guide to Creative Darkroom Techniques*) are complicated and time-consuming.

1. For maximum contrast with minimum effort, near silhouette of dandelion was made by exposing 35mm Kodalith in camera printing negative on No. 6 paper.
2. To make reflection-like effect, an Ektachrome-X slide was projected on sheet of Kodalith film. After processing and opaquing, it was printed for top portion, then flipped for the bottom.

For those who like their effects in a more direct manner, try using Kodalith in the camera for the original exposure. Working with a rating of 10 as a base line, shoot a test roll and bracket the exposures to determine how closely this approximates the film speed that will work best with your particular lens/shutter combination. The result is an in-camera negative ready for printing after development, but it should be examined carefully for pinholes which must be opaqued out before moving to the enlarger. If you're shooting 35mm in-camera, you'll need a magnifier and a steady hand with the opaquing brush, but good work is not impossible.

Just as there are times when you use contrast in a black-and-white print to add or enhance a certain mood/feeling in your picture, there will be times when the same effect will add to the effectiveness of a color transparency. Since it's possible to create high-contrast color by the choice of techniques and film, let's look at a few.

Until a few years ago, Kodachrome-X was the best emulsion to use for high contrast, since it was known as a very gutty film with the grainless quality for which Kodachromes are noted. But Kodak came forth with SO-456, now known as Photomicrography Color Film 2483, a very contrasty film with great resolving power. Created for use in scientific applications where high definition is required, 2483 has a rated ASA of 16 in daylight

and ASA 4 under tungsten illumination. Due to the high contrast that's inherent in the film, it has very little latitude—about one-half stop over/under. But the beauty of this special-purpose emulsion is that it can be processed with standard E-4 chemistry.

While intended for photomicrography, as its name indicates, it *can* be used whenever you want or need extreme contrast. One ideal use comes with distant landscapes when a high haze level in the atmosphere cuts down the contrast. It's also great for adding pep to the normally low contrast of overcast days; like No. 6 enlarging paper with a low-contrast negative, it really brings dull pictures to life.

Subjects shot in very soft lighting will also turn out well with 2483, but using it with people in bright sunlight produces a harsh, unflattering effect. One striking use for the film is in creating silhouettes, since the extreme contrast will help achieve a complete silhouette often unobtainable with other films.

While 2483 records magentas, reds and blues very well, with super-saturated colors that pop out at you, it has a tendency to go over to the blue side, and so pictures taken in the shade may turn out rather cool. To prevent this, you can use either gold tinfoil or a gold Reflectasol to bounce some warm light onto your subject, or use a warming filter—an 81A or 81C will do nicely. Since each emulsion batch differs

slightly, it's best to make a test to see how much filtration is required.

But suppose that ASA 16 is too slow for your purpose—what then? I'd recommend either Ektachrome-X or High Speed Ektachrome pushed one or two stops for the extra contrast. Ektachrome-X works best because it has more inherent contrast and with a two-stop push, you have a rating of 250, which should handle most situations.

It's also possible to add contrast to an existing transparency by duplicating it with a slide copier and 2483 film. A first-generation copy should double the contrast, but if that proves insufficient, recopy the dupe. This will make your second-generation slide four times as contrasty as the original was. To avoid losing any more sharpness than is necessary, the use of a macro lens is recommended for copying. Of course, nothing beats contact printing for sharpness and if you have a darkroom, this method of duplicating a slide is preferable to using a slide copier attachment.

INFRARED

At some point in their quest for special effects, most serious photographers cross paths with infrared film—this tricky-to-use film can produce spectacular results in either black-and-white or color. Infrared film is used extensively in landscape and aerial work because of its ability to cut through haze and smog, in architectural photography and for producing night effects. It's also excellent for high-key figure studies shot outdoors, since skin tones will reproduce white while the sky background becomes a near-black.

Exposure is one of the problems that makes infrared a difficult film to master if used only occasionally. Since photoelectric light meters cannot read the amount of infrared energy present in a scene, start with the recommended exposure of one second at f/22 with the required red filter over the lens for black-and-white. A High Speed Infrared film (ASA 50) is also available; Kodak recommends an exposure of 1/60 at f/16 for distant scenes in bright sunlight when using this emulsion, with an increase of two stops when photographing nearby subjects instead of landscapes.

Because of its sensitivity, black-and-white infrared film can be fogged quite easily by heat and light. To prevent this, load your camera in complete darkness the night before you plan to shoot. Since you may need more than one roll of film on location, always keep a changing bag handy to remove the exposed roll and insert a fresh one. Store the exposed film in its can and in a *cool* place until you're ready to process it.

Focusing is another problem inherent with the use of black-and-white infrared film. Since infrared energy does not focus at the same focal point as visible light rays, lens focus must be altered to correct for the longer infrared wavelengths. Most modern lenses are equipped with a tiny red dot on the focusing scale to be used instead of the standard focusing index mark. Correction charts have been published for use with older lenses not so marked.

Because black-and-white infrared film is considered to be a medium-grain emulsion, don't plan on blowing up your negatives more than 4-5X or the grain will begin to show. Kodak recommends development in D-76 for normal contrast or D-19 for maximum contrast. Since infrared is a fairly contrasty film, I find that 10 minutes at 68°F in D-76 produces excellent negatives.

Incidentally, you can have a wild time photographing objects that give off heat rays, such as electric heaters, toasters or the common household flatiron. Set your camera on a tripod, turn out all the lights with the appliance on and bracket a series of time exposures. Exposure will vary depending upon the appliance, the amount of heat it puts out and the distance from camera to subject.

Since infrared portraits have a macabre appearance, you might also try infrared flash shots. Freestyle Photo Sales occasionally offers GE No. 5R infrared flash bulbs for sale; these emit only a deep purple glow when they go off and were quite popular a couple of decades ago among teenage photographers who delighted in sneaking pictures of their friends necking while remaining unseen.

Infrared color is just as tricky as black-and-white, but the results are simply dazzling. Originally manufactured for military use, infrared color film was used to detect camouflage—living foliage reproduced as red while artificial foliage and other objects painted green photographed as blue—but once it became available in 35mm back in 1964, infrared color proved an instant success with those seeking special effects. Although it produces color pictures that are incredible, infrared color is also very finicky and unpredictable—you're never positive of just what will happen when you load up and shoot.

Photos taken at high noon will differ greatly from those taken at sunset—far more so than the differences with regular color films. All of the black-and-white filters, Color Compensating filters, Light Balancing filters and special colored gels can be used and each will produce surprisingly different results.

If you've never worked with infrared color before, start experimenting by shooting from 9 a.m. to 4 p.m. and using three basic filters—the G (orange), X1 (green) and 23A (red). The orange filter turns the sky a brilliant green while trees and grass become a bright orange or red, depending upon the amount of chlorophyll in the foliage, and

whether it's in the sun or shade. Rate the film at E.I. (Exposure Index) 64 with the orange filter.

Using a green filter and an E.I. of 32 will produce a rich, deep blue sky with reds changing to yellows and foliage shifting to magenta, while skin tones take on a purple glow. With the red filter and exposures calculated at E.I. 64, a blue sky becomes a vivid green but turns yellow on an overcast day. Shrubbery becomes a brilliant orange in sunlight and more reddish under overcast conditions. The red filter is also good for photographing a model; the colors will be offbeat (mainly yellow and green) but the effect is interesting (to all but the model, who may scream when she sees the pictures). Soft light from a window or open shade helps to tone down excessive contrast when working with people as subjects.

While I've provided E.I. ratings that work well for me, the amount of infrared energy present varies from day to day and even hour to hour. Because of this, it's advisable to bracket your exposures one stop on each side in one-half stop increments, or five exposures. Remember, too, that infrared energy is both invisible and highly variable. The advice given above will work more often than not, but when it doesn't work, be prepared for a disastrous experience. The entire roll may come out looking as though a roll of normal color film was shot

Kodak Royal-X Pan film developed in DK-50 can be used for extreme grain effects. The more grain in the picture, the fewer details you should include.

through an orange, green or red filter if the level of infrared energy was low. As a general rule of thumb, avoid exposing infrared color on overcast days—nothing is quite as ghastly as a monochromatic puce-green when you're expecting many brilliant and different colors.

Otherwise, the same basic rules used with black-and-white infrared film work with infrared color, with a couple of exceptions. The color film is not quite as sensitive to being loaded and unloaded in daylight, but do refrigerate before use and after exposure if development is to be delayed. Incidentally, development is done in standard E-4 chemistry and it's fun to watch the weird colors pop up on the film as it dries.

The infrared focusing mark is not used with infrared color as two emulsion layers are sensitive to visible light waves—green and red. But it's always a good idea to stop the lens down as much as possible; if you find it necessary to use a wide lens opening for effect, then focus on the front edge of the primary subject. One of the first and most effective subjects for the beginner working with infrared color is foliage—green trees, bushes, grass or any other green plant—the more chlorophyll the foliage contains, the stronger the reflection of infrared energy and the brighter the colors.

GRAIN

For the imaginative photographer, the built-in grain

of high-speed black-and-white films makes them ideal for special effects, and far superior to the so-called grain texture screens. In my experience, Kodak Tri-X and Royal-X Pan have it all over the other fast films, including 2475 Recording Film. While the latter is favored by many, the grain pattern in this emulsion is not as sharp as that of Tri-X or Royal-X Pan. This may sound a bit strange, but grain sharpness is very important to good results, and soft grain just doesn't have it.

As a special effect, grain looks best when the photograph was made under low light levels, since this is what most people have come to associate grain with, and it therefore looks more believable. Overcast days with gray skies produce very good scenics for use with the grain technique, because grain shows up very well in large masses of gray tones and the mood created by this type of lighting accentuates the effect.

Rated at ASA 1250, Royal-X Pan has considerably more grain than Tri-X (ASA 400) but is not available in 35mm loads. To eke out the maximum grain from either emulsion, you need a high-energy developer such as Acufine or Kodak DK-50. Doubling the development time lets you push the speed rating up two full stops, thus Royal-X Pan developed for 10 minutes (instead of five) in DK-50 gives an effective E.I. of 5000. I would recommend such a boost only

Used properly, infrared film can create an eerie and mystical mood. As the green foliage turns to a light gray tone, it adds to the apparent contrast by making the tree trunks and branches more prominent.

when working under poor lighting conditions where the light was also very soft and flat, since the increased development time will also boost contrast considerably. For most situations, the best technique is to add a minute or two to development time while cutting exposure by one-half to one f-stop.

A few handy tips—to maximize grain effects, don't fill the frame when composing. Keep the subject in the center and crop when enlarging. The additional degree of enlargement will emphasize the overall grain effect. You can also make the effect more pronounced by using a high-contrast paper such as Agfa No. 6. And when working under the enlarger, you'll find that using a grain focuser will be a big help in focusing on the grain pattern itself rather than the image.

Carry a neutral density (ND) filter with you; it's often necessary to slow down the increased speed rating in sunlight just to expose the film at the camera's maximum capability, usually 1/1000 second at f/16. Other times, the light may not exceed exposure capabilities, but you might need to use a large f-stop to limit depth of field.

Most of us look for a grainless quality in color films but grain in a color shot can add to the mood, making the picture's statement much stronger. When fast color films like Kodak High Speed Ektachrome or GAF 500 are pushed, the grain becomes coarser and

produces a salt-and-pepper effect. The grain also stands out in different colors, giving the picture a texture-screen effect that's better than using a texture screen in the first place.

Shooting for a grain effect in color works best when the subject is kept simple in design. Subjects with a minimum of detail such as the sky, a soft or out-of-focus background, a large body of water, etc. let the grain effect show up at its best.

Pushing color film is a simple matter of prolonging the length of time your film is left in the first developer; each additional minute will give approximately a one-quarter f-stop push or increase in speed. While a good custom lab can push your film considerably, it's best not to go beyond two stops, because the black areas begin to fog and turn dark gray. Of course, if this is the effect you desire, then push as much as you like.

For readers who prefer color prints to transparencies, you can work color miracles by simply processing Ektachrome films in the C-22 chemicals normally used for Kodacolor/Ektacolor materials. In addition to the color reversal effect, there are several other factors to consider. Contrast increases considerably, as does color saturation or intensity, while the effective film speed more than doubles.

At first glance, this all sounds great, but looking at these side effects more carefully will show you that cer-

tain limitations are placed on your choice of subject matter and lighting. Let's look at the extra film speed first. When developed normally in C-22 chemicals, both Ektachrome-X and High Speed Ektachrome appear to have about the same speed increase potential, although I use the former at E.I. 400 and the latter at 500.

While extending development time will further increase the effective speed (a 100-percent increase with High Speed Ektachrome will produce an exposure index of about 1200), this also increases contrast and color saturation. Strangely enough, the increase in these two factors is considerably less with High Speed Ektachrome than with Ektachrome-X. But you've got to watch that contrast build-up. In certain cases, such as working in the shade or with the soft lighting through a window, it can prove useful. It also works well when shooting a distant scene through a telephoto lens, where maintaining contrast and color saturation can be difficult because of atmospheric haze, which refracts light rays and gives a diffused appearance to the picture.

But shooting what most of us call a normal subject can be deadly, as the excessive contrast build-up can make printing virtually impossible. The thing to look for here is the *abnormal* subject, and even then you may want to use a diffusion or fog filter over the lens to lower the contrast somewhat.

Selective exposure combined with a choice of a highly simplified subject is one effective way of using this technique dramatically. Choose a scene of normal contrast and color intensity that contains shades of a single basic color. Expose for the midtones and the shadows will go black while the highlights go white, further simplifying the composition while accentuating the single color through the intense color saturation.

If you expose for shadow detail, these areas of the subject will print in detail while the overexposed midtones and highlights print white. Exposing for highlights will produce good detail in those portions of the picture while allowing midtones and shadows to go black. By this point, you can see that this technique used effectively is really an exercise in imagination *and* experimentation.

There are a lot of effects that can be achieved easily with the proper choice and use of film and technique; once again, it's a product of your imagination just as with anything that's creative. What I've done in these pages is to show you a few of them to jog you along if you've been thinking about working with special effects but resisted the temptation to invest a great deal of money in special gadgets and equipment. As you can see, some of the simplest but also highly effective ones require no additional tools beyond your camera and your mind. □

optics for effect

Most of us who buy a camera and take a serious interest in photography eventually reach the point where we feel that something new is needed to add freshness to what has become a rather stale viewpoint; at least that's how we rationalize the purchase of more equipment. There are even some who seriously believe that simply throwing a few accessories into the gadget bag (or buying a new bag itself) will make us better photographers. It isn't true, but why kid ourselves? It's fun.

For the serious amateur, this first addition to his equipment is usually a second lens to augment the one that came with the camera body. Although a few who can afford the tariff become enamored by the mere possession of extra lenses and acquire every new and different piece of glass that's offered, for most of us, the purchase of a second or third lens is a ritual act to be thought over very carefully in an effort to pick the right one for our needs. As a result, we end up with a medium telephoto and perhaps a moderate wide angle.

These are great for the majority of needs that arise in day to day shooting, but if you really want to put lenses to work in special effects photography, you're going to have to move to the extremes—with both telephotos and wide angles—because that's where the action is. Unfortunately, laying out several hundred dollars

To add a round world feeling to your fisheye pictures, point the lens downward. This causes the horizon line to curve. If you shoot into the sun, you won't have to worry about getting your own shadow in the picture.

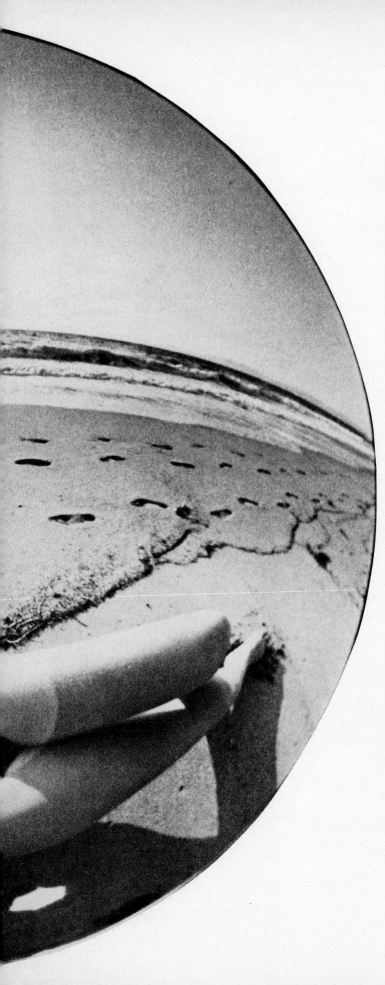

(or more) on a single lens—whether it's a fisheye or a mirror tele—is not an act to be taken lightly; you realize that the lens won't be used enough to justify tying up all that money in a single hunk of glass. Of course, for the professional, it's a different story—the ability to carry out a specialized assignment or breathe fresh life into a stale idea given by an art director may hinge upon having just the right lens at hand. Passing up too many such assignments will eventually cost the pro more than the price of a lens, and so it's usually the professional who keeps optical houses in business figuring out new and different formulas for exotic lenses.

But if you know what you're doing and where to look, you too can get in on the action without breaking the budget in pieces for months to come, and on the following pages, I'll not only show you exactly what you can do with the more exotic lenses available, but also how you can get around the cost factor in many cases. Let's focus our attention on the widest angle of the lens spectrum first, with a look at the fisheye concept.

When they were first made available several years ago, the fisheye lenses made a big splash and everyone who could pay the price rushed to get into the act. As a result, the 180-degree effect provided by these superwide lenses was quickly overworked and soon became a photographic cliché. Today,

the fisheye has fallen somewhat into disfavor simply because most photographers don't use it with care and thought. As a result, much of what we see taken with fisheye lenses are just gimmick shots rather than ones that really work.

But like any other piece of photographic equipment, the fisheye lens can be a very creative tool, providing that it's used correctly. Get deep enough into this field and you'll come to realize that there are certain times when nothing but a fisheye will really achieve the effect you're looking for. Basically, there are two types of fisheye lenses: one that gives you a complete circular image and one that provides a full-frame or almost full-frame image. To make the differentiation a little more practical for the reader, I've elected to call the latter superwide instead of fisheye, and we'll get to them a little later. Right now, let's consider the complete circular image and what you can do with it.

Our first concern is simply what you can do with the fisheye lens. The best answer for the novice is experiment—time and time again. As you work with a fisheye, you'll discover that certain types of subjects seem to work especially well with the round image; things that have a circular or semiround design to them, such as the ceiling of a dome or a winding staircase, or even the inside of a pipe. Aerial shots also work very well because when you shoot straight

down, you achieve a global or round world feeling with this lens.

The distortion inherent in 180 degrees of coverage is considerable and you must be aware of it at all times to make it work for you in making a statement about your subject. If you keep your subject in the center of the frame and a fair distance away, it's possible to minimize the distortion with the fisheye lens just by keeping the horizon line in the center and not allowing any vertical lines to run along the sides of the frame. When you think about this for a moment, you're bound to realize that this rather restricts the subject matter, and it does, if eliminating or minimizing distortion is your aim.

But let's suppose you want to get the same global effect you would with an aerial shot, but without taking your feet off the ground. If you keep the fisheye perfectly level with the horizon line running directly through the middle of the frame, it will be as straight as an arrow, but tilt the lens downward slightly to place the horizon line in the upper half of the frame and watch the effect appear as the line begins to curve. You've seen the greatly exaggerated perspective obtained by having a person stick his hand out in front of the lens, but have you considered photographing a flat surface head-on and making it bend on all sides?

You can also work with some interesting effects from the sky. Lie on the ground with the camera pointing directly up; cloud formations take on an entirely new look from this vantage point. Or, you can have someone stand close to you, which will put him in the foreground of your picture. However you choose to handle it (and the aesthetics are up to the individual), distortion produces some knockout effects provided you don't go overboard without a reason. It's mainly a case of knowing when to apply it.

If you've checked into the price of a fisheye for your camera, you already know they don't come cheaply. In fact, merely looking at a list price of $2600 for a fisheye to fit the Kowa Six can turn you off faster than anything I know. Even those designed for 35mm cameras would make a good down payment on a new automobile, so perhaps you're wondering why I'm extolling the virtues of experimenting with a fisheye lens for special effects when many readers just can't afford to obtain one. Well, things aren't really that bad, if you're willing to compromise just a bit.

The original popularity of the fisheye effect was so great that one of the first things accessory lens manufacturers did was to design a fisheye conversion lens. Soligor, Spiratone, Samigon, Kalcor, Astranar, Prinz and several others all offer essentially the same design under their trade names and what's even better, you're not locked in to using this device with only the camera you originally purchased it for. Adapter rings can be obtained to let you use the fisheye conversion lens with almost all 35mm and 120 cameras using 67mm or smaller filters. With the proper adapter, it can be used with practically any lens whose focal length ranges between 30mm and 200mm. If you already have a wide-angle, normal and medium telephoto for your camera, the fisheye conversion lens can be used with each and will produce a different effect with every one.

There are, however, a few limitations, but considering the fact that you can obtain one for between $60 and $100 (depending upon the brand and where you buy it) instead of $600 to $1000, a couple of slight handicaps really aren't too much to live with. The first, of course, is quality. You can't expect that a conversion lens is going to give you the same quality you'd get with a specially designed prime lens, but let me assure you that unless you plan to enlarge the prints beyond the usual 8x10 or 11x14, you won't notice the softness at all. With color slides, the situation is just a bit different. Projecting a slide shot taken with one of these fisheye conversion lenses will work O.K., as long as you're not aiming for theater size and quality. Or, if you're not a professional photographer who plans to sell the pictures, this limitation should not bother you in the least.

Another limitation comes in the effective aperture of the conversion lens; this ranges from f/3.5 to f/90 and depends upon the focal length of the lens to which it's attached, not the speed of the prime lens. When you screw the conversion lens and adapter into your prime lens, open the prime lens to maximum aperture and focus on infinity. At the rear of the conversion lens you'll find a milled ring marked from 30 to 200; this should be set to correspond with the focal length of the camera lens to which you've attached it. Directly in front of this are a cutout that reads in f-stops and a second milled ring with an index dot for setting the aperture according to the exposure required. So here's the limitation—the longer the focal length of the lens on which it's used, the slower the speed of the combination.

Since the fisheye conversion lens multiplies the focal length of any lens to which it is attached by a factor of 0.15, it will turn a 30mm lens into a 4.5mm wide angle, a 50mm lens becomes a 7.5mm wide angle, and a 135mm converts to a 20mm equivalent. Because of this factor and the universality with which it can be attached to most camera lenses, the fisheye conversion lens becomes an ideal investment for the serious amateur who is eager to expand his capability in the area of special effects. You can have a lot of fun with one without mortgaging the

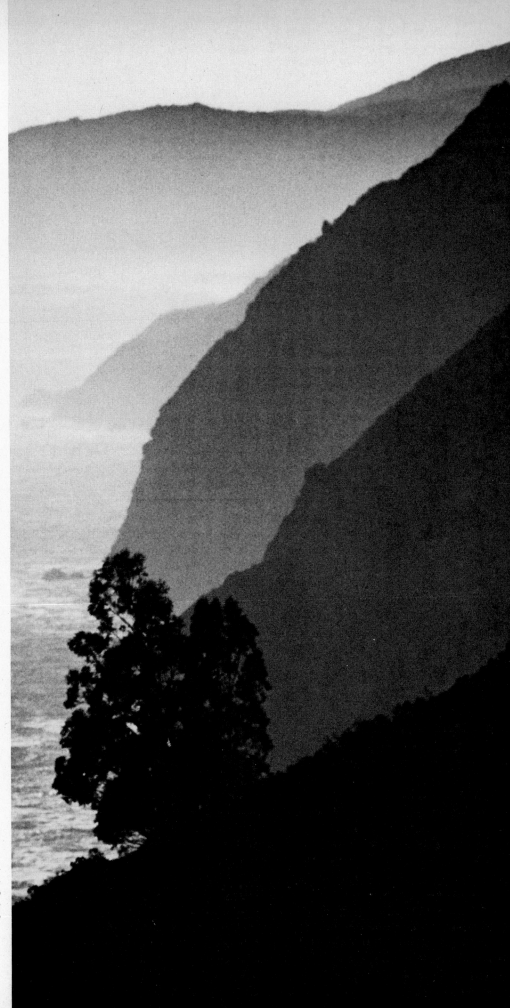

homestead to pay for it, and if you trade cameras or buy a second one, you don't have a useless hunk of glass cluttering up the closet shelf. Just spend an extra $2.50 to $5 for another adapter ring and you're back in business.

Spiratone also makes a 7.5mm and a 12mm fisheye lens available at moderate prices. These are T-system lenses and replace the prime lens on your camera instead of converting it. The T-system allows interchangeability between various cameras, but not to the extent provided by the adapter ring mounting that is used with the conversion lens.

The lenses I've chosen to call superwide can produce some very dramatic and exciting pictures when used in a creative way rather than just for the wide coverage they offer. Superwide lenses also come in two types: those designed for maximum coverage and those designed for minimum distortion. The ones referred to as fisheye lenses (even though you get a full-frame image) provide maximum coverage but you also have maximum distortion and can make vertical or horizontal lines bend just as you would with an 8mm round fisheye. The superwides that minimize distortion as much as possible do not have as great an angle of coverage even though the focal length may be the same for an equivalent fisheye lens. Unlike the circular fisheye shots, which are a dead giveaway to how you made them, pictures taken

The only way to obtain this compression effect where the mountains appear to be stacked up closely behind each other is with a supertele lens. Mountains are actually many miles apart.

with some of the nondistortion superwides can be most deceiving since they make objects appear to be much bigger, longer and taller than they really are. Seeing is believing, as the old saying goes, but you can lie very easily with a superwide lens.

Those who are really serious about photography should have both types of lenses with which to work, since there will be times when you'll want and need the distortion, and other times when you don't. Superwide lenses to fit a 35mm camera range in focal length from 15-24mm. In my work, I use basically three lenses that fall into this category and would recommend anyone considering them to acquire two in the 15-17mm range, one corrected for distortion and one fisheye type. The third should be either a 20- or 24mm focal length.

You'll find with superwide lenses that only through trial and error can you begin to find out what works best insofar as subject matter, degree of distortion, subject-to-camera distance and other related factors are concerned. In the process of using one or more superwide lenses, you'll develop an eye for distortion that can add a touch of grace and beauty instead of something that looks grotesque and ugly. And as you train your eye, you'll be able to tell just by looking through the viewfinder whether the distortion is right or not.

Many amateurs who acquire superwides go over-

board with distortion and soon come to develop a healthy distaste for the effect once its newness has worn off. They photograph everything in sight with the new lens and before long, it ends up at the bottom of the gadget bag, pushed to the back of the closet shelf or worse, traded back to that friendly dealer for another oddball optic. The key to success here is restraint—lots of it.

For example, if you fit a 15mm wide angle to your camera body and then try to fill the full 35mm frame with a head-and-shoulders shot, the result most certainly will be unflattering, both to the model and to your talents as a photographer. But if you use a 24mm lens at the proper distance and angle from your subject you can turn out a beautiful picture. Angle is very important whenever you're working with wide-angle lenses. Composing for a full-frame shot of people from a high camera angle will produce an oversize head and undersize legs and feet, and unless you require this special distortion for a particular reason, the shot just won't work right for you. Stay away from those high-angle shots; in most cases, it's best to keep the camera at waist level to avoid the excessive distortion between the feet and head.

Since superwides have a tremendous amount of depth of field, take advantage of it. Framing, or having an object or person very close to the lens in the foreground, is an excellent technique that will give your picture a three-dimensional quality. If you're photographing a girl at the beach, shoot between her legs and use them as a frame for another subject such as a sailboat. Or place a pair of sunglasses on the sand in front of your lens and then frame the subject in one lens of the glasses.

Properly used, a super-wide lens will allow you to shoot straight down on a subject and still show the horizon line. Try this with a model resting on the sand near the surf around sunset and you'll get the waves, ocean and the setting sun, all in one picture. This same technique can be used with many other subjects—try photographing the inside of a glass or can and still see what else is on the rest of the table.

Shooting into the sun will give one kind of flare effect with some of the superwide lenses, but a completely different type of flare is also possible—one that comes from photographing objects whose lines extend out toward the camera lens. The subject could be something as simple as a baseball bat, a boat oar, an airplane wing or even someone's hand or foot—anything long and narrow works well, but the lens must be very close to the object's end in order to produce the maximum perspective divergence distortion.

TELEPHOTO LENSES

Once you've explored the wide angles, it's time to give the telephotos a try. Now, when I talk telephoto, I'm not referring to those mousy little 135mm or 200mm lenses, nor even the 300-500mm variety—I'm speaking of the long lenses—800mm and up! Unfortunately, there are no conversion or adapter lenses to make a little tele a big tele—not even using a 3X converter with a 300mm lens will do the job adequately.

1. By using a superwide lens and shooting from a low camera angle, you can add dramatic impact. The amount of distortion can be controlled by camera-to-subject distance and by relative height of camera to subject. 2. An anamorphic lens can be used to make your subject taller and leaner than reality. A thin girl looks like a matchstick.

So if you have a yearning to get into the supertele end of the lens game, you're going to have to lay out a chunk of money, but look at it this way—you saved a bundle on the wide angles with that fisheye conversion lens and you can afford to spend it on a telephoto. Besides, for occasional use (and that's exactly what the supertele will get), there are a few manual and preset diaphragm lenses on the market that will serve the purpose. There's no need for most amateurs to blow a small fortune on a Nikkor or Canon supertele—Caspeco, Vivitar and Soligor all offer 800mm teles at a comparatively modest cost, and you can often pick these up used at a healthy saving.

Which brings up a good question—what about used lenses? There's probably no better bargain in photographic equipment than a used superwide or supertele lens, if you shop around. As I've pointed out, many amateurs hock body and soul to buy one new, use it a few times and then stash it away somewhere to collect dust until a new fancy strikes. Then they rush back to their favorite camera shop, plunk it on the counter and make a trade that costs them an arm and a leg. As the dealer knows from past experience that he's not going to move a used supertele as fast as he could a 135mm or 200mm lens, he's more apt to put a reasonable mark-up on the lens to get it off his shelf. And here's where you come in—if the dealer has a

reputation for backing up the used merchandise he sells—buy it. There's very little that can go wrong with a long lens provided that it hasn't been dropped or otherwise mistreated. If you have the choice between a low-cost supertele and a better used one at about the same price, opt for the used one.

The type of supertele, that I use most often is the mirror-reflex or catadioptric lens. This unique piece of glassware utilizes a reflective system employing mirrored optical surfaces, a design that enables very long focal lengths to be folded into an extremely compact package. Mirror lenses usually combine reflective surfaces and refractive correcting lenses with very high color correction. Their major drawbacks lay in the impossibility of incorporating an iris diaphragm, and the large front area of the system, which makes filtration a problem.

The lack of an iris means that the lens is always wide open—it works at a constant and nonchangeable f-stop. But exposure can be varied by manipulating the shutter speed or by using neutral density (ND) filters. Most mirror lenses incorporate a built-in filter system. The usual selection consists of a skylight or UV filter plus red, yellow and orange filters for black-and-white photography. Color filtration can prove a bit difficult but I cut gelatin filters and insert them *behind* the lens, taking care not to let them interfere with the operation of the mirror in the camera.

Even so, any way you look at it, the advantages of using a mirror lens far exceed those of a long focal length optic. I've found that a mirror lens in the 1000mm range (give or take a couple hundred mm) works best, as the 2000mm lenses are just too powerful for the majority of subjects and make the problems of working with superteles just that much more difficult to cope with. But before you break the piggy bank for your dash to the local photo shop, let's see what can be done with the mirror lens, as well as some of the problems you can expect in using it.

The first thing you'll run up against is the problem of acquiring what I like to call the "one-degree vision," after the angle of view of the supertele. You see, the 1000mm is such a powerful lens that you'll find that you're often too close to your subject, unless it's fairly small. For example, to get a 40-story building in your viewfinder, you'll have to be six or seven miles away from it. In fact, at the minimum focusing distance of most such lenses (usually 20 feet or so), you can fill the frame completely with just a person's face. Unpacking the supertele, hooking it onto the camera body and setting up just to check a shot to see if you're in the ball game can be quite a chore, so I suggest that you work out a system with your camera and a certain lens as I did.

To check out a potential

picture, I fit my 105mm lens on my Nikon F body and view the subject with the small split-image circle in the middle of the viewing screen. This covers almost the precise area that the 1000mm lens will include, and saves me all that effort every time I wonder if the supertele is the lens I really want. You should be able to work out a similar approach using the split-image circle or microprism of your camera as a guide, with either a 105mm or 135mm fitted to its body (some circles and prisms are either larger or smaller than others).

The slightest vibration can cause unsharpness in your picture when working with a supertele. You might think that a good, heavy-duty tripod would take care of such problems, but it takes a bit more. One of the primary causes of vibration is a phenomenon called mirror slap. When the mirror goes up and hits the top, it causes a slight vibration which is greatly amplified with this type and size of lens. The best way to overcome it is to release the mirror first, then click the shutter. This can be done with some 35mm SLR cameras, and on some, it can't. But even so, there's a disadvantage here—by the time you've got the mirror up and out of the way, your subject has probably moved, unless you're working with a model or other fairly stationary subject. Nikon F owners can have their cameras adapted so that the mirror can be flipped up using a

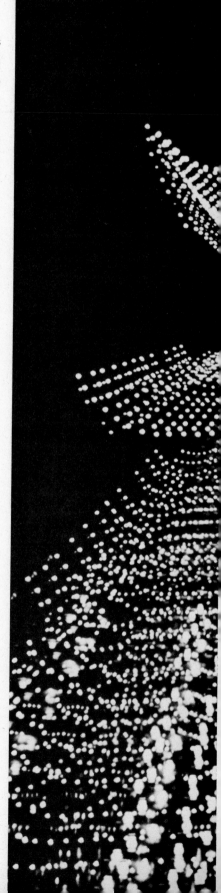

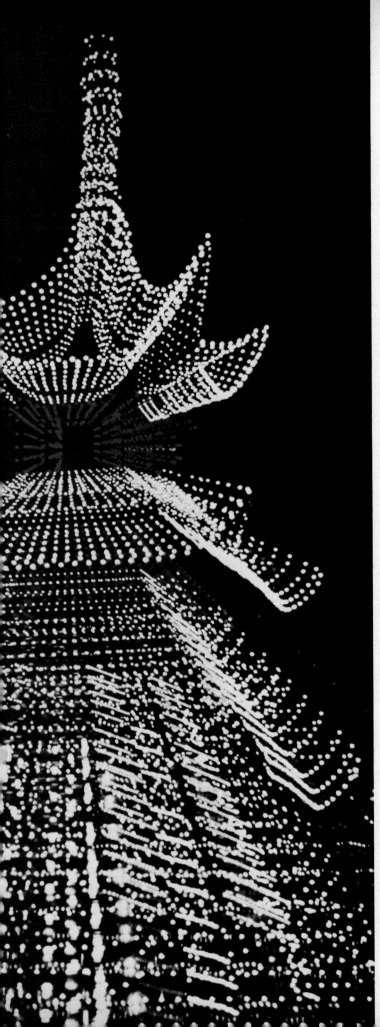

cable release. This gives it time to settle down before the shutter goes off. Camera Service Center of Culver City, California, calls this adaptation the "mirror pre-release" and charges between $45-65 to make it, depending upon the age of your Nikon F.

Once you've solved the mirror slap problem, there's one other major difficulty that causes vibration—the wind. It doesn't take very much wind to move your lens and the best answer to overcoming this problem is to find a shooting location where the camera is shielded from Mother Nature—in a doorway, beside a wall, etc. As you might expect, such handy shelters are seldom placed where you want to position the camera, so you'll probably have to resort to draping a small sandbag over the lens. If you really have to get a picture from a certain position where it's very windy and there's no convenient shelter that can be utilized, build yourself a small A frame wind block by using two pieces of plywood large enough to extend from camera back to lens front and set the camera close to the ground on your tripod.

Atmospheric conditions and lighting will also provide their share of headaches—see why the casual user seldom sticks with a supertele for very long? With normal or moderate telephoto lenses, you hardly notice problems such as haze, smog or heat waves, but with the 1000mm focal length, everything is greatly magnified. The ideal day for working with the supertele is one that's very cool (fewer heat waves coming up from the ground) and very clear. Early morning is usually a good time for shooting, before the ground starts to heat up. The only problem with waiting for a clear day is that this kind of weather in many areas of the country is usually accompanied by a strong wind.

Shoot in bright sunlight, if at all possible. It's more contrasty than an overcast day and atmospheric haze causes a considerable loss of contrast when photographing subjects that are several miles away from the camera. Sidelighting is excellent since it picks up more detail, which in turn makes your picture appear to be sharper than one taken under diffused light conditions. For the maximum in contrast and impact, shooting directly into the sun with your subject positioned in front of it can't be beat.

One of the major reasons that most amateurs buy superteles is to photograph sunsets with that big ball of fire dominating the frame, but not all sunsets are worth shooting and many people become discouraged when they see the results of all their time and money. Actually, the best type of sunset for this kind of picture is when there's some atmospheric haze in the skyline—it makes the sun appear to be larger and softer. I say appear, because as we all know, the sun does not get

Amusement parks such as Tivoli Gardens in Copenhagen have many lighted buildings and provide a cornucopia of subjects on which different night effects can be tried. This shot required eight separate exposures at different focal lengths with zoom.

special effects/19

larger or come closer to the earth during sunset, but if there's sufficient haze in the air, it will magnify the sun, making it seem larger, and thus more effective in your picture.

If you plan to shoot sunsets with a supertele, I strongly advise that you acquire a solar filter. This is one of the few filters that can be installed in front of the lens and it performs a simple but vital task—that of blocking infrared and ultraviolet rays to protect your eyes while looking directly at the sun. Many amateurs feel that a strong neutral density filter is sufficient, but remember that infrared and ultraviolet energy is invisible to the human eye, and just because a neutral density filter cuts down the illumination sufficiently to let you squint through the viewfinder, it does nothing to protect your eyes. The *only* time that it might be safe to look through the lens without a solar filter in place is during a sunset that's so covered by haze that you can look at it without sunglasses and without squinting. But even when it's very subdued, you should use extreme care and good judgment when working with long lenses and the sun. After all, you're greatly magnifying both the image and intensity of the sun, and focusing that image on both the film plane and your retina could cause untold damage—so get a filter and protect those eyes!

One of the most beautiful effects that can be achieved

with a mirror lens is the doughnut circles caused by bright highlights in the subject background, as when the sun hits a lake or the ocean. Every one of those bright highlights will magically turn into a pleasant little doughnut, and here's the time to try a little creative filtration (covered at length in the filter chapter) to add color to the normally white highlights.

Combine this effect with a model in your picture and you'll really wow your friends with your new-found skill. Since telephoto lenses in general tend to make people appear somewhat heavier than they really are, I suggest that you choose a slender model for this type of work, since the 1000mm really adds the pounds. You'll have some problems in communicating with your model, since you'll be approximately a full city block away when taking full-length shots. I've found that placing a walkie-talkie near enough for her to hear it (but out of camera view) works best for me, although you can probably devise a series of hand-signals that will work nearly as efficiently for occasional shooting sessions.

From what I've said to this point, you may have already concluded that the supertele is highly unsuitable for action photography—not true! Granted, limited depth of field with a long lens, mirror slap, vibration, the wind and other factors do enter into the picture, but I've found that there are three general

types of action situations that work well with the supertele lens:

1—Action that you know will happen at a predetermined place, such as home plate in a baseball game, the goal post in a football contest or on any corner at a road race. Here, you simply take your time and compose your picture, focus and even flip up the mirror, then wait for the action to take place.

2—Action that comes toward you in a straight line where you will not have to move the camera. For example, you might be positioned at the end of a track with the sprinters coming straight into the lens. In a case like this, the runners will not be moving out of line and you won't have to be focusing as you snap the shutter.

3—Action that moves parallel across your lens at a moderate speed. A racing sailboat is an excellent subject for this type of shot; a jet airplane is not. The latter is especially hard to center if you're trying to fill the frame. Of course, practice makes perfect, but how many of us can spend that much time photographing jet airplanes overhead?

But don't get me wrong on that last statement; throughout these pages, I've encouraged experimentation and trial-and-error efforts not only as a way of developing an eye for what you're doing, but as the only way you'll really learn about various effects and how they can best be put to work for you. One super shot from

the whole roll is a good batting average for most, and if you can get that, you'll agree that it was worth it. But now it's time to move into other areas where you can exercise your creativity and one of the most versatile tools in the lens arena is the zoom.

ZOOM LENSES

The zoom lens offers more creative photographic potential per millimeter than any other optic on the market, and everyone interested in special effects should have at least one zoom in his gadget bag. Unfortunately, most amateurs have the wrong one. With the great improvements in optical quality and

1. Gelatin filters can be cut to size to fit between the lens and T-mount adapters instead of adapting filter to front of lens.
2. To minimize vibrations, drape a small sandbag over the lens.

the generally lower price tags of zoom lenses in recent years, many amateurs forego the wide-angle or telephoto prime lens as their first lens purchase and opt for a zoom, usually a medium range such as the 70-210mm or 90-230mm focal length.

Fascinated by the variable focal length, they discover too late that this particular range is not exactly the best for what they plan to do. Those who buy inexpensive zoom lenses find that the focus and zoom rings are too loose to work with the camera hand-held and any degree of real accuracy. A slight change of hand position on the lens barrel while composing the shot can change everything. The answer is a tripod, but who wants to lug one everywhere he goes?

The zoom lens is often considerably heavier, bulkier and makes the camera body more difficult to hold steady than a prime lens. Sharp pictures with the camera hand-held mean using a shutter speed of 1/250 or faster and that can be a restriction depending upon the lighting conditions. These and other factors begin to pile up and pretty soon the zoom lens finds its way to the back of the closet shelf, along with that superwide lens that didn't work out the way its owner planned it.

2

It's really a shame, but where many photographers go wrong is jumping into the zoom game before they really think it through. Basically, there are three ranges of zoom lenses: the short range, such as the Nikon 43-86mm or Tamron's new close-focusing 38-100mm; the medium range, which takes in the 80-210mm zooms; and the long range with a focal length from 200-600mm. You'll find the short-range zoom to be the sharpest, as well as the least expensive for the degree of quality involved. You'll also find that most professional photographers own and use a short-range zoom more often than any other, and I'd recommend that you consider this as your first zoom—it's very compact, light in weight and versatile.

The medium-range zoom is really the most popular type with amateurs, and can be very useful when you need the extra focal length in situations where you're confined to a particular position and cannot move in closer—when photographing sports action, for example. Long-range zooms are heavy, costly and must be used on a tripod if you hope to get anything approximating maximum sharpness. By themselves, these three factors limit the popularity of the long zoom, but for the wildlife or sports photographer, it's almost a must.

In order to achieve special effects with a zoom lens, you're going to have to mount the camera on a tri-pod, since you'll be working with slow shutter speeds and changing the focal length of the lens during exposure. Since the shutter speed will be somewhere between ½ second and two full seconds in order to give you time to zoom the lens, you'll need a slow film such as Kodachrome 25 or Panatomic-X, and will work with the lens stopped down all the way. If there's still too much light for a correct exposure, place one or more neutral density filters over the lens. You can read dozens of articles on techniques, but nothing will take the place of your own experiments and testing.

When you're ready to make the exposure, there are two ways of zooming during the time the shutter is open—up the focal length (43mm to 86mm) or down the focal length (86mm to 43mm). Each way produces a different effect. If you're not certain which way will be most effective with your subject, then do it both ways. Generally speaking, you'll find that zooming down the focal length produces a better effect since the image in the center will be clearer. Zooming up the range gives more of a double exposure effect along with a ghost image aura.

Will you want to zoom the entire range during the exposure? Not always; it depends a great deal upon your particular subject. Sometimes a full zoom is just too much—the subject becomes unrecognizable. To prevent this from happening, you can

limit the zoom to a portion of the range. Rather than zoom from 86mm all the way down to 43mm, stop at 70mm or perhaps 55mm. This also works well when you want only a small amount of blur.

Another way around this problem is to make two separate exposures. The first is made with the zoom lens set at a fixed focal length, say 43mm. Then when you make the second exposure, you zoom the lens as desired. This will produce a good sharp image of the subject as well as the streaked blur effect. When using the two-exposure technique, I've found that it's best to make the first exposure at the shortest focal length and then zoom up the range, but again, choice of subject matter really dictates which way you go. Either way, a dark background works best and shots made at night are highly effective.

Another multiple-exposure technique that makes use of a zoom lens is to make two or more exposures with the lens set at different focal lengths—you do not zoom during exposure. Select your subject and position the camera on your tripod, then determine how many exposures you want to make. I usually work with three to seven, although I have gone as high as 12 exposures for a single picture. Now the problem is simply one of calculating exposure. Every time you double the number of exposures on a single piece of film, you reduce the *amount* of exposure by one

f-stop. Thus, with two exposures, you close the lens down one full stop; with four exposures, you close down two full stops, and so on. This technique works very well when you have a subject lighted from behind (rim lighting) and a dark background, producing what could be called a tunnel effect since you end up with a series of images that telescope inward.

Certain types of lighting work especially well with these zoom techniques, while others are very tricky. You'll find isolated lighting the easiest to work with. City lights at night are a favorite starting point, since you have a dark background into which you can zoom the lights. City skylines that have tall buildings and lighted windows are also popular as well as neon signs and amusement parks. Since the windows in most buildings use only white light, try using colored filters to add color. Make more than one zoom exposure and use a different filter each time.

Backgrounds that contain highlights also work fine with the zoom techniques. Look for aluminum foil, water highlights or light streaming through a grove of trees—all are excellent backgrounds that will add punch and drama to your zoom effects. If you have a five-image prism attachment (one with a single image in the center and four images around it), try zooming with it for effect, but hold back on the amount of zoom. In this way, you'll

get the center image fairly sharp with the four outside images blurred.

Add a feeling of motion to something like a parked racing car by using a slow shutter speed and zooming during the exposure with the car facing toward the lens. Or try panning a fast-moving object while zooming the lens at the same time. This creates an off-center zoom which, combined with the blur of the pan, produces a very dramatic effect.

Don't be afraid to take the camera into the studio for a zoom shot. Place a model against a black or very dark background and position two spotlights at 45-degree angles behind her for rim lighting on her hair. You'll also need a flash placed next to or a little above the camera for frontal lighting. Now set the lens at its shortest focal length and the shutter at its one-second setting. When you trip the shutter, the frontal lighting will fire and then you begin your zoom up the focal length during the remainder of the exposure. As the spotlights are still shining on the model's hair, they will create a streaked halo effect as the light flares out from her head during the zoom.

You can also make dual portraits in a similar manner. Make the first exposure with the zoom lens set at its maximum focal length with the model wearing a black sweater. Then have the model change into a bright red, green or yellow sweater and resume her position. Set the zoom at its minimum focal

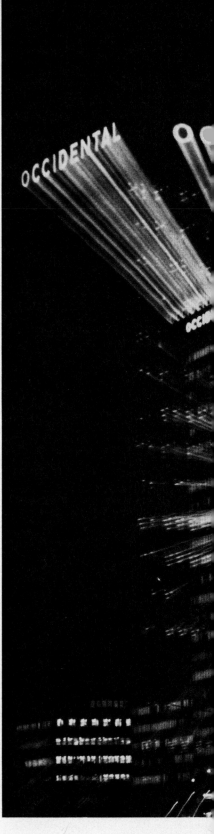

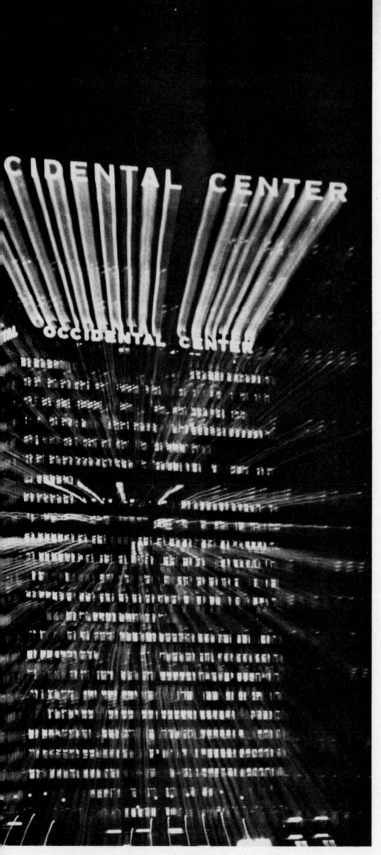

Zoom effects at night are simple since large areas of darkness surround the subject. Two exposures were used here; an ordinary time exposure with the lens set at 43mm, and a one-second exposure during which the lens was zoomed out to 86mm.

length and if necessary, move the camera slightly so that the second image will superimpose on the black sweater of the first exposure.

ANAMORPHIC LENSES

Use these ideas as jumping off points for your own imagination and you'll find the creative potential of a zoom lens to be practically unlimited. But before we leave the world of optics, there's one other piece of glass that we should look at briefly. While not as well known to still photographers, primarily because their original use was intended for motion pictures, anamorphic lenses have some unique qualities for those seeking special effects.

Advertising photographers with automotive accounts soon discovered that they could really emphasize a long, lean and sexy look when shooting pictures of cars with an anamorphic lens, effects similar to those seen in CinemaScope and other wide-screen movies (which are taken with an anamorphic lens). A wide-angle lens will also add apparent length if you shoot from the front or back of the subject, but with one major disadvantage—size distortion. The end of the subject closest to the lens will appear much larger in size than the other end. Here's where the anamorphic lens comes in, provided you use it correctly.

There are several varieties of anamorphic lenses available, but by far, the one most practical from a price standpoint is the Schneider Iscorama, which is essentially a 50mm f/2.8 lens with f-stops down to f/16. The Iscorama design consists of two parts: the rear portion, which is a prime lens of normal construction containing an automatic diaphragm, and the front portion, which contains the anamorphic lens elements and is equipped with two protruding fingergrips. The anamorphic effect is controlled by depressing the fingergrips and rotating the front elements. Depending upon how you position the front portion of the lens, you can: lengthen your subject to make it appear longer than it really is, shorten your subject by squeezing it together, and distort your subject to make it seem to be leaning over diagonally.

In my experience, I've found the anamorphic lens works best when the subject itself is already somewhat tall and lean, or short and fat, as these qualities add to the effect. For example, photographing a tall, thin model with the anamorphic lens will let you really exaggerate her figure. You can do a similar trick with a fat person, making him look just that much fatter. And if you have any stout friends, you could do them a favor and take off about 60 pounds with the anamorphic.

Uses for the anamorphic aren't limited just to making your friends appear to have been victimized by sideshow trick mirrors, but as with any form of optical distortion, you have to use good judg-

ment in applying it. By adapting the anamorphic to fit your enlarger, you can create a new effect with negatives already in your file. Or, you can take the original picture with the anamorphic and then double the effect by enlarging it through the lens. A circular fisheye shot can be turned into an oval, and so on.

If you haven't already unloaded your purse on a battery of extra lenses for your camera, you can see at this point how much you can do in special effects photography just by the judicious choice of the glass you buy. For example, instead of shooting for that 35mm and 105mm prime lens wide-angle and telephoto set, acquire a short-range zoom. What you save on a fisheye by going for a fisheye conversion lens will let you pick up a good used mirror telephoto—just sit down and *plan* your expenditures before you make them. Now, it's time to move on to another area of special-effects photography. □

These two land formations were actually miles apart, but the compression effect of the mirror lens combined with exposure for the sky added a dramatic punch.

blurred images

There are several ways you can add excitement to your pictures by controlling exposure or the relationship between shutter speed and lens opening. The easiest techniques for a starting point are those used to produce night shots with light trails—essentially a long exposure made after dark. This is not the ordinary time exposure made at night, but one that contains light movement, and there are two basic ways you can make such pictures: photograph subjects with moving lights or move the camera during the exposure if the lights are stationary.

Night traffic is a good example for those new to after-dark photography. You can photograph traffic on freeways, turnpikes or other heavily traveled arteries, at intersections, on city streets, or even entering and leaving parking lots. You'll want to shoot most often from a high camera angle in order to record various patterns of light that moving vehicles will trace on the film while the shutter is open; a bridge over the road, a hill near the highway or the top of a nearby building will give you a good vantage point.

Exposures for this type of special effect can vary anywhere from ½ second to four or five minutes, depending upon the film in use, the maximum aperture of your lens and the effect you want from the traffic. With short exposures up to five seconds or so, the light streaks from the cars will reproduce as short dashes; longer exposures will create long streaks of light. If you're working with color film, try using different colored filters over the lens during the exposure—you'll be surprised at what this can do for your picture, especially if you can manage to change the filter one or more times during the exposure period.

Another subject that's quite effective with this technique is to photograph someone holding a portable source of light such as a common flashlight, a lantern or even a neon tube connected to a dry cell battery. Probably the most popular use of this is made each Fourth of July as sparklers are set off across the entire country, but recent new firework prohibitions may dry up this subject matter entirely.

Twilight is the best time since there's enough light remaining to record the basic form and outline of your subject, but it's still sufficiently dark to use the portable light source. You might go out to the local airport and try a shot of a ground control worker directing a plane into its parking place; they use a lighted cone flashlight in each hand as they motion directions with their arms. If you can still find one that's active, a railroad flagman at the switch as he swings his red lantern makes another ideal subject for this technique. Use a one- or two-second exposure for shots like this. Your imagination will surely turn up many other examples—you might like to attach a couple of lights to a friend who skis and photograph him coming down the slope just before dark.

CAMERA MOTION

Ever have the yen to photograph a city skyline at night? Usually the results on film hardly seem as exciting as the scene you visualized at the moment you released the shutter. Try jiggling the tripod during the exposure and you'll come up with a shot that is truly different. You may not like the results immediately, but at least you'll be getting yourself out of a longtime rut. While you're experimenting to discover exactly what types of camera movement produce pictures that are exciting, remember that most often you're going after an abstract effect, so don't hold back when it comes to moving the camera around.

Since many city skylines are very narrow, they produce pictures with a thin row of lighted buildings running horizontally across the picture area with large black areas above and below—so why not fill this space up? Point your camera downward until the buildings occupy just the top portion of your picture frame and make a normal time exposure. Once that is complete (and with the shutter still open), begin panning the camera upward until the lights from the buildings move into the bottom of the picture area.

To vary the effect, you can jiggle the camera while you

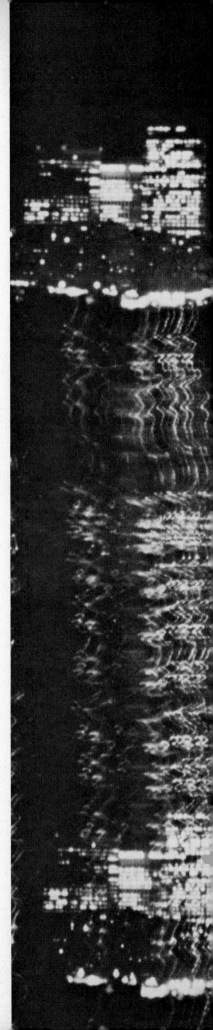

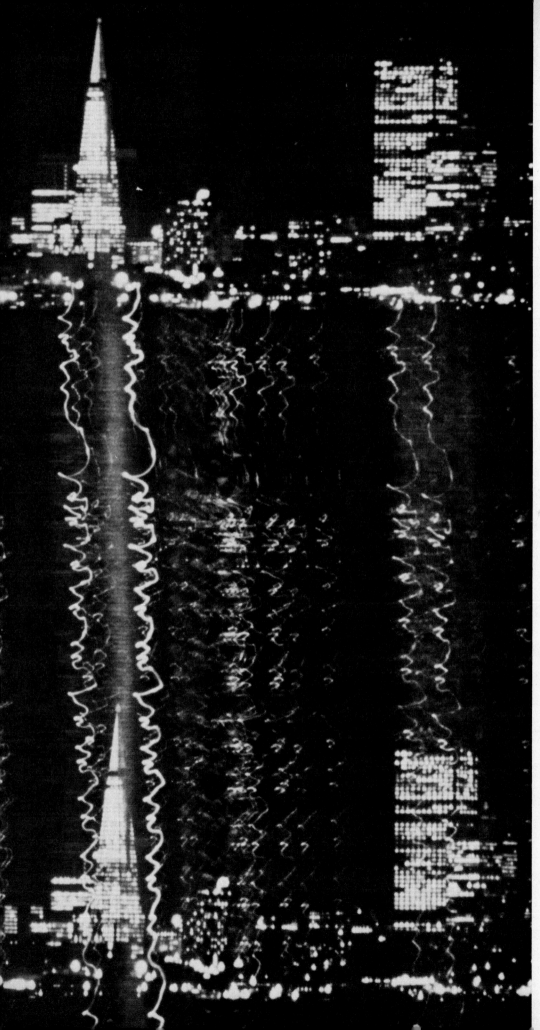

move the camera upward; this will produce a wiggle effect in the light streaks that are being exposed in the black area of your picture. Or, hesitate several times during the upward pan and you'll get multi-images of the skyline. The combinations are really limitless, so why not expose an entire roll trying various movements. The end result is a mixture of reality with the abstract.

If abstractions fascinate you, make your picture completely abstract by moving the camera from the time you open the shutter. You don't even need a tripod for this effect—just open the shutter and start moving the camera. Only light streaks will show up with this technique, and no two designs of the same subject will turn out to be identical. Point source lights seem to work best for this; look for outdoor Christmas lights, undiffused amusement park lights or any bare bulbs of the type you see hanging in strings across used car lots.

If you try working with slow films such as Kodachrome 25 or Panatomic-X, don't forget the effects of reciprocity failure. With exposures exceeding one second in length, film emulsions lose some of their speed, requiring a longer exposure than indicated by your meter. For example, Plus-X requires an increase of one full stop for a 10-second exposure and Ektachrome-X needs two full stops for the same exposure. If you don't care to get technically in-

To obtain this effect is probably one of the simpler techniques herein. Position camera so that skyline is at the very top of the frame—then, with shutter on bulb, open shutter and hold camera steady for a second or two to record skyline and pan camera upward with a sort of horizontal wiggly motion.

special effects/27

volved to the point of determining the exact degree of reciprocity failure, be sure to bracket your exposures on the long side. To do so, make sure that you open the lens diaphragm correspondingly rather than extending the length of exposure, since the reciprocity effect is compounded as you lengthen the exposure, and your attempt to correct it in this manner is self-defeating.

PANNING

Most of us tend to think in terms of a high shutter speed whenever we aim our camera at a moving object. This is only natural, since we've all been taught that our pictures should be as sharp as possible, and this means stopping the action. A number of years ago when electronic flash first hit the professional field, we were deluged with peak-action pictures in which everything and everyone seemed to be frozen in time and space. The only problem with these pictures is that they lack a feeling of speed and motion, failing to communicate properly with the viewer.

By panning the camera as motion picture photographers do (or following a moving subject in the same direction of its motion and at approximately the same rate of speed), it's possible to record a perfectly sharp subject and still have the foreground and background blurred. This takes a good deal of practice, but it's well worth the effort because the resulting pictures you create

will really have the feeling of motion/speed in them. You can also use the pan technique with objects that move quite slowly—someone walking or riding horseback—and make them appear to be speeding by the camera.

Perhaps the best assurance of having a sharp image of a moving object when panning is to put the camera on a tripod. By adjusting the tripod head to move only in a horizontal direction, you can keep the camera from moving up or down, or tilting to the left or right. Tripods equipped with a ball-in-socket head are not really useful here, since they allow the camera to move in any direction and you want to restrict such movement.

To record the moving subject as sharply as possible and still have a blurred background, the right shutter speed is of utmost importance. You'll want to use the fastest speed that will still allow the background to blur. Exactly what that speed is depends upon a number of variables. The main factor, of course, is the speed of your moving subject; the faster its motion, the higher shutter speed you'll need. With most action shots of race cars, speedboats, motorcycles, etc. that move at high speeds, a shutter speed of 1/125 down to 1/15 second usually works best. If the subject makes more than one pass across your field of view, bracket your shutter speeds and take several shots. This will better your chances that at least one will

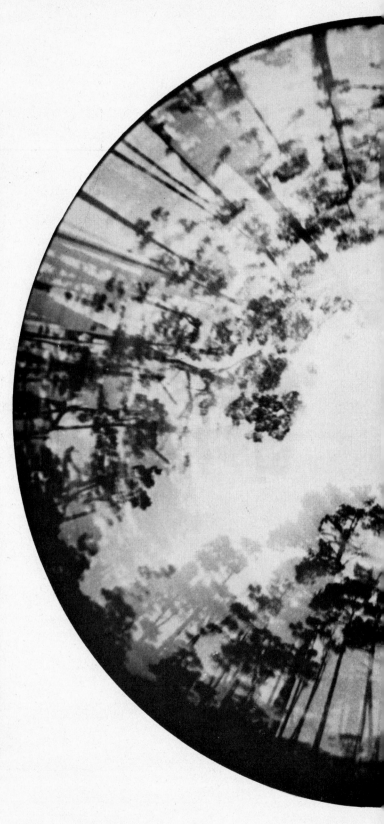

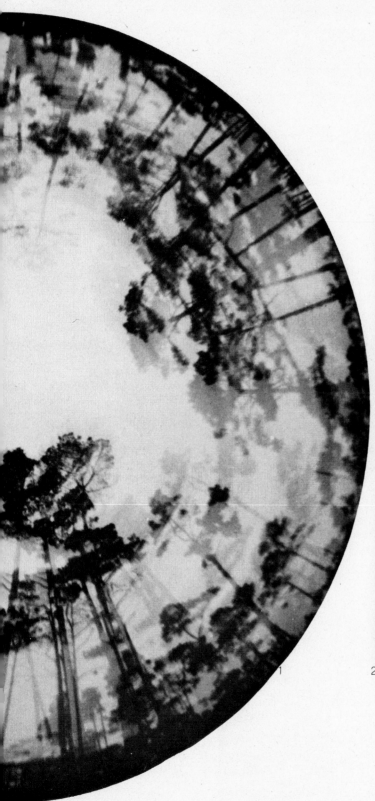

be on the button. For other types of action, such as those found during sporting events, you can usually get away with speeds anywhere from 1/60 to 1/2 second.

When your moving subject is a person rather than a race car, you'll also find that part of the subject will be blurred even if your panning technique is perfect, since the arms and legs of a human in motion move at different speeds and directions than the body. But this will also enhance the mood and feeling of the sport or action in which the subject is involved. Just be careful not to

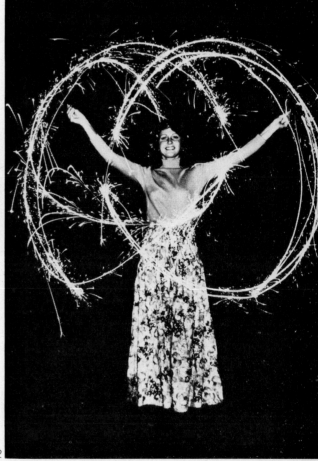

1. With a fisheye lens on the camera, it was pointed straight up and swirled during the three-second exposure. Swirl motion works best with wide-angle lens. 2. For this effect, be sure to position the subject far enough away to get in all of the light pattern—focus with aid of a flashlight. Open shutter while model swings sparklers around, fire flash, then close shutter.

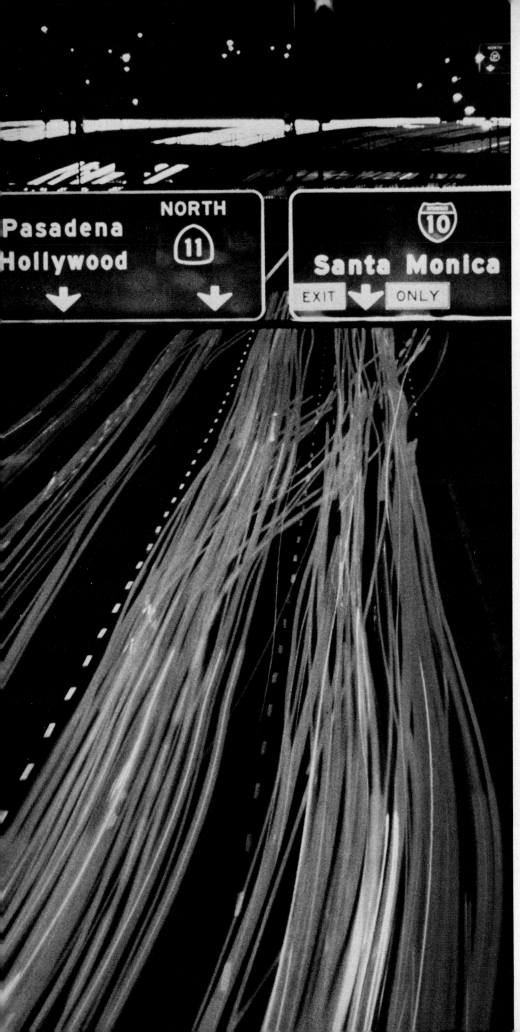

use too slow a shutter speed or part of the arms or legs may actually disappear!

But don't limit the use of the pan technique just to racing cars and sports; pan with a slow shutter speed on anything that moves—children playing, horses trotting along, birds starting to take off into flight or even people just walking by.

The time will come when you may have to pan without a tripod. As with the night-time exposures, this is absolutely in order if abstraction is your goal, but for any other result, it's usually less than perfect, primarily because few of us can pan that well unaided. If you don't have the use of a tripod, change to a shorter lens, if possible, since you'll be able to control and steady it much easier. It may even turn out that both subject and background are blurred, but the subject is still recognizable and thus carries plenty of impact.

Working from a moving vehicle is not really the same as panning despite the fact that the end result is often similar. This is one of the best ways to photograph action, and one of the easiest once you get everything set up correctly. For example, suppose you want to shoot a girl water-skiing. You could stand on the shoreline and possibly get off one or two shots every time she passed by. But to end up with a decent choice of effects, you'd have to spend all day. You might be able to stand it, but she probably wouldn't.

Highways that are heavily traveled at night make excellent subjects. Shoot from a high camera angle and find offramp where cars are likely to change lanes. A 20-second exposure was used to record traffic in this shot.

Now suppose that you have access to another speedboat that could run alongside of her—you could shoot a whole roll of film almost as fast as you could wind it through the camera. In addition, you'd be traveling at the same speed as your subject, thereby cutting down the possibility of blurred pictures from using a slow shutter speed. By maneuvering your camera boat to pull ahead or fall behind, swing in toward or away from her, you could also shoot from various angles that would be impossible to get from shore.

Naturally it's important that the vehicle (speedboat, car, etc.) you use rides as smoothly as possible. If your ride is very choppy or bumpy, then you'll have trouble keeping your subject sharp (and in frame) even though you're traveling at approximately the same speed. When working from a boat, it's best to wait until the wind dies down so the water will be calm; in a car, you should choose a road that has as smooth a surface as possible and little traffic. Hopefully, you're not foolish enough to try driving and shooting pictures at the same time—get someone else to do the driving.

Backgrounds are very important when panning for sharp pictures. Suppose you try panning an airplane in the sky—the sky is light, the plane is light and there's nothing to show the motion or blur. Locations that have busy, many-hued back-grounds work best, especially in color. A background of trees and bushes with strong backlighting is ideal because the highlights will turn into streaks when the camera is panned, and this really makes the picture come alive with action and excitement. Shooting at twilight with night lights in the background that will blur also enlivens the picture.

Many photographers never advance beyond the stage of keeping their pictures totally sharp; after all, they've worked hard for many years to get good, sharp pictures and the thought of moving the camera during an exposure of a stationary object is unheard of. Since most of us have been preconditioned to keep the camera still during exposure, the following is a technique that has hardly been overworked. So if the subject doesn't move, then move the camera. But before doing so, consider *how* you're going to move it. Basically, there are five ways or directions you can go: a vertical pan, horizontal pan, diagonal pan, a circular or swirling motion, and a jarring or jerking movement. Each produces a different effect and some work much more effectively with certain types of subjects than with others.

Tall buildings and trees, or a model in a standing position work nicely with the vertical pan. Buildings usually photograph best at twilight when there are lights on in the windows but there's still enough outdoor illumination to show the form and shape of the structure. Strong backlighting streaming between trees gives interesting results, just as when used for a blurred background. If you're working with a model, have her wear bright and colorful clothing and use a dark background into which you can smear the colors. I've found the double exposure technique described under zoom lenses to be most effective, since part of the picture will contain a sharp image of her (see page 22 in chapter II).

By now, you're probably ahead of me and realize that horizontal subjects work best with the horizontal pan. A parked dragster makes a good example, because it has a basic horizontal shape associated with great motion and speed. Now here's the challenge—you want to photograph the car in motion but it can't be moved. Set your camera on a tripod, use a shutter speed anywhere between 1/30 and ½ second and pan the camera. Start the pan before opening the shutter and continue the movement throughout the exposure. If you try to start the exposure at the same time you begin to pan, the exposure may be over before your reflexes have had a chance to start the pan, especially if you're using speeds such as 1/15 or 1/30 second. The end result of this technique will be a totally blurred effect.

Another way of creating apparent motion is to combine a partial blur with partial sharpness by making two ex-posures. With the camera set on a tripod, make the first exposure, then recock the shutter and pan the camera during the second exposure for the blur. Unless you're working against a very dark background, each exposure should be one stop less than normal to produce a correctly exposed final result. A variation of this is to use a long exposure in the neighborhood of a full second and pan the camera during the last part of the exposure—a handy trick if your camera doesn't have a provision for double exposures.

THE SWIRL

Used properly, the swirl can be very effective. By rotating the camera around a central axis, the center of the picture retains a good portion of detail while the outside edges of the picture are completely blurred. Use of a super-wide lens such as a 20mm or 15mm on a 35mm camera is highly recommended, since you'll get much more movement on the outsides of the picture in relation to the center than with a longer lens.

The swirl technique works well on subjects with highlights that can blur into circular lines to create a kind of tunnel effect. Shooting down on things like flowers or sparkling highlights in a puddle of water adds a different dimension to rather standard camera fare. It's also great with action subjects that travel in circular directions, such as a gym-

nast executing a somersault or a child on a swing. Don't get carried away, however, and try to rotate the camera a complete 360 degrees; you can achieve interesting results with just a brief swirl.

THE "JERK"

This brings us to the "jerk" or "jiggle" technique, which is essentially the same as moving the tripod. You can use this technique in a couple of ways. One is to strike the camera or the top part of the tripod with your hand during the exposure. This will cause a blur that's different from that achieved with a straight pan. The question of how much to move it is one that can be answered only by practice and bracketing. It differs with each subject and there's no real way you can measure and duplicate the same degree of jiggle every time.

The second approach to this technique is to actually take hold of the camera and jerk it slightly—up and down or from side to side. Any subject that's very bold and graphic and doesn't depend upon lots of detail for it to *read* is suitable for this seldom-used technique.

USING FLASH

The combination of flash and subject movement requires a degree of preplanning, but the effects you can produce are well worth the effort. While any camera can be used, a TLR works best since it allows you to see what's going on in the picture area during an exposure

that can run up to 15 or 20 seconds while the subject moves around. Flash bulbs or electronic flash may be used but for best results a unit with a guide number of at least 35 to 40 and up will be required unless your subject is very close.

This technique will allow you to produce a sharp picture with the flash and a blurred picture of the subject in motion with your slow shutter speed. You'll need a location where you can control the level of illumination since it must be in proper ratio to your flash exposure. This means that working indoors is almost essential. If light enters the room through a window, closing the drapes part way is one method of control. Another is to adjust the intensity of the lights by dimming or by moving them in relation to your subject. In some cases, diffusion discs might even be necessary over the lights, which must be balanced to match the color temperature of your flash, unless you're working in black-and-white.

(To achieve proper color balance between tungsten light and electronic flash there are several methods—we suggest the following for its simplicity and economy. Keep in mind that most tungsten light has a color temperature of 3200 to 3400° Kelvin while electronic flash units emit light nearer to that of daylight or 5500°K. The best way to reconcile the difference is to load your camera with daylight film for use with the electronic flash unit

and filter the tungsten light at its source for the required balance. Daylight conversion colored gels are available for this purpose from Berkey Colortran in 24x24-inch sheets of Mylar for $3.75 each—order Light Sky Blue. For varying effects, the gels also come in several other colors. If you plan to work frequently with the tungsten/electronic flash or daylight combination, there is another way to go—though a bit more expensive it also lasts a great deal longer. Larson Enterprises, Inc. makes reflectors in several colors marketed under the Reflectasol label. It's possible to convert tungsten light to the color temperature of daylight by bouncing it off the Silver Blue model, available in several sizes and shapes to accommodate many types of subjects.)

To determine the correct exposure with your flash unit, use the normal procedure of dividing the guide number by the distance in feet from the subject. Use an ordinary light meter to measure the tungsten light. Place the subject in front of a black or very dark background and position the tungsten lighting on the side of the subject opposite from the flash. Adjust the intensity to allow a shutter speed of from ⅛ to two full seconds. The exact speed you select depends upon the effect you desire and the movement of your subject. The longer the exposure, the more blur you'll get; the faster your subject moves, the less ex-

posure you'll need.

After adjusting the lights and selecting a particular shutter speed, determine the lens opening for your flash unit as described above. Now back to your regular meter, since the tungsten lighting must be readjusted until it reads one stop overexposed. This is necessary

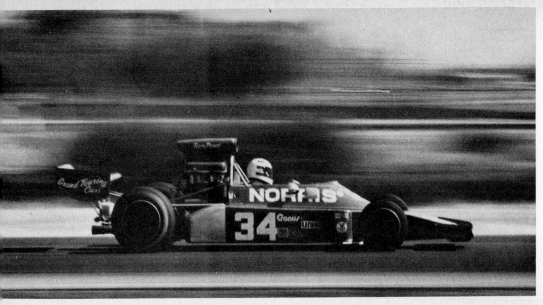

because the subject will move during the entire exposure while the flash will be expended during only a brief portion of it. Bracketing is again recommended, since you may find that the cumulative effect of flash and tungsten lighting make an f-stop of ⅓ to ½ less than you planned on more effective. □

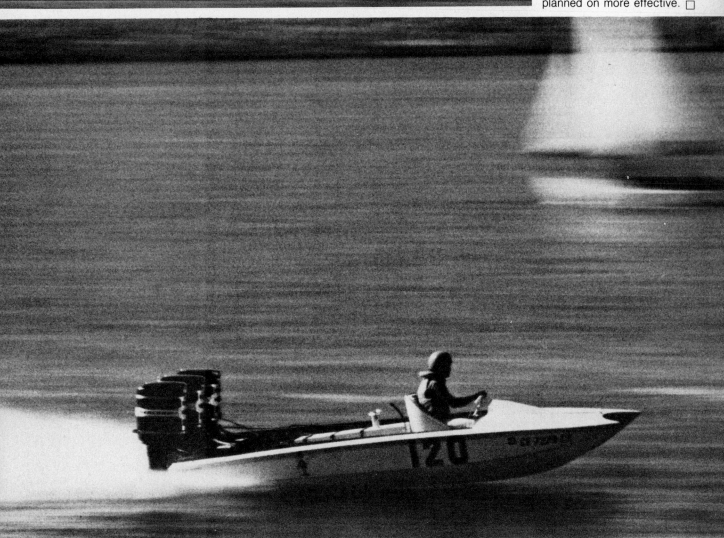

Horizontal pans with subject moving across your field of view are simple once you've practiced a bit. You'll find that pan shots of race cars are somewhat easier to obtain than those of racing boats. One reason is availability and opportunity (there are motor racing tracks all over the country) and the other is one of technique. Shooting on solid ground is always easier than trying to steady a camera already set for a slow shutter speed from a boat. Good race car shots are usually obtainable from behind spectator fence with 135-200mm lens.

the total spectrum

The total spectrum. Color. Why? What? How?

As to why, we can only speculate. What, is seen clearly evident in these pages. How, is what this book is all about.

We won't go into a discussion of what color is or what effect it can have on all of us—that can be a very personal thing, a very private thing, often introspective.

What we're dealing with here is color for color's sake alone—Ken Biggs' vivid perception and interpretation of what he saw and how he saw it—that's all that's really important, isn't it?

But what kind of man made these remarkable images? What kind of dynamic personality must this man have to divine photographs that range from the softly diffused with a near dreamlike quality, to others that are brilliant splashes of color washed upon the film much as a fine artist would mix and create forms and textures with the freedom of oils or water colors?

Ken Biggs is a quiet man—a modest man—but one with a vitality, sensitivity and awareness that is rare indeed. He is eminently capable of communicating his feelings about the world around him to others with tremendous impact—another rare quality.

Meet Ken Biggs—see as he sees—enjoy—and then learn/*Charlene Megowan.*

An 80B filter was used to give cool tones to this sunrise shot on the island of Maui. Spectacular results are possible by shooting directly into the sun when clouds or haze disperse the light.

1. This shot wasn't nearly as difficult to obtain as it might appear. Just choose a model with dark hair to add contrast to the neutral background and shoot through a 25 (A) red filter.

2. This picture is basically a three-section prism lens shot with a bit of creativity mixed in. For that little something extra, use tiny pieces of two-sided tape to attach different colored gels to each facet of the prism.

3. Color grain effect was achieved by using a high-speed color film and pushing it a stop or two to accentuate the pattern.

4. Pleasant diffusion technique is result of shooting through Pic-Trol unit originally designed to be used on the enlarger.

5. Las Vegas showgirl was photographed with combination of strobe and tungsten lighting, a tripod and a zoom lens.

1. With the 3-M Color-Key process, all your dull black-and-white negatives can be turned into exciting colors. This Color-Key shot was made with a black Kodalith and four Pantone colors: 206, 246, 300 and process blue.

2. To achieve this beautiful effect you'll need a light box, a piece of black paper to cover it, a seashell, some dime-store glitter and a flashlight. Cut a hole in the black paper somewhat smaller than the shell, place paper then shell on the light box and sprinkle with glitter. During exposure, shine the flashlight on the subject to pick up resulting highlights with cross-star filter.

3. This circular diffraction grating will produce drama and color but the lens must be pointed at a point source light.

4. Backlighting situations can be improved by the use of filter meant for black-and-white film—here, a G (orange) was used to increase contrast and add color.

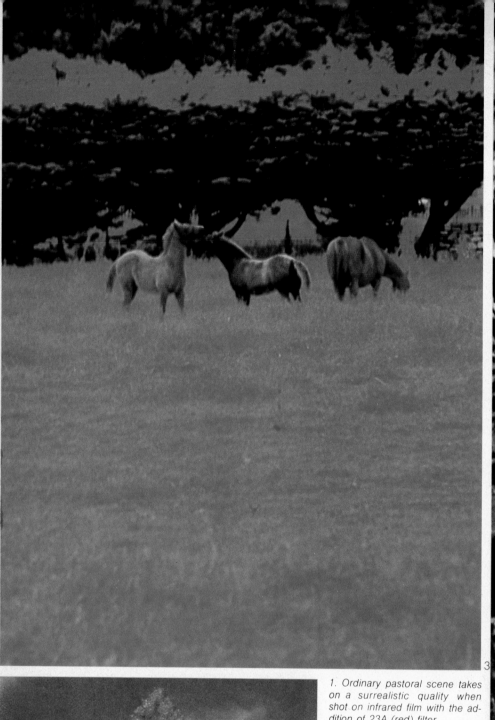

1

2

3

1. Ordinary pastoral scene takes on a surrealistic quality when shot on infrared film with the addition of 23A (red) filter.

2. Infrared film and an X-1 (green) filter placed over the lens turned the green foliage a vivid magenta while the sky went a dark blue. An E.I. of 32 works well with infrared and X-1.

3. If you don't mind green skin tones, infrared can be very striking in work with people. Again, a 23A filter was used while the film was rated at E.I. 64.

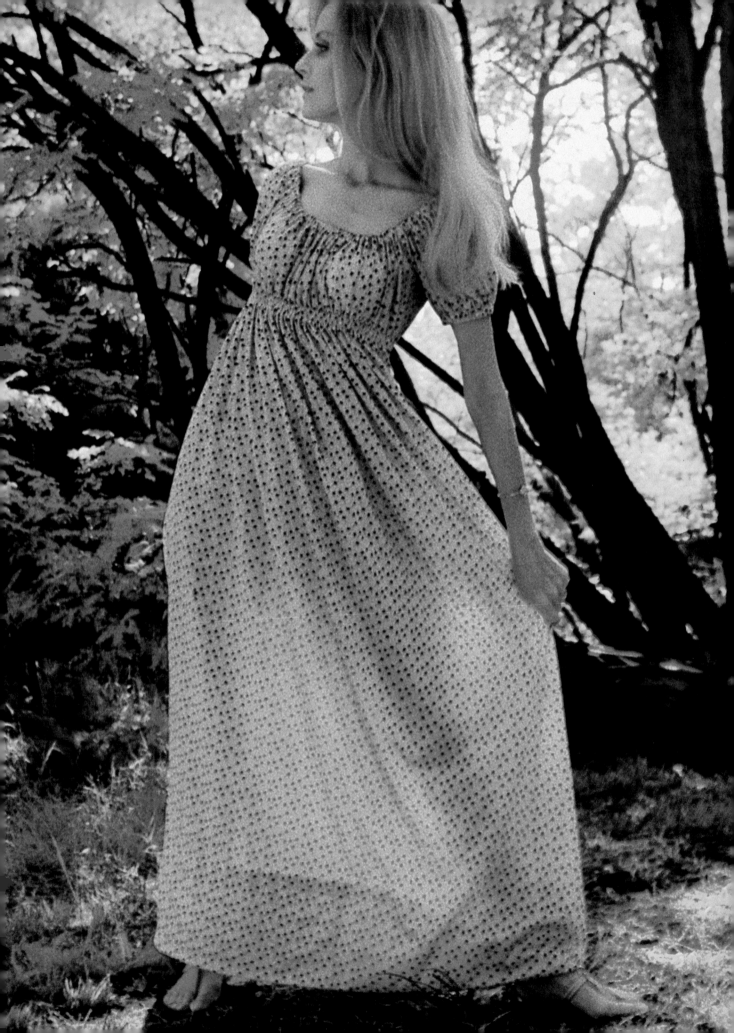

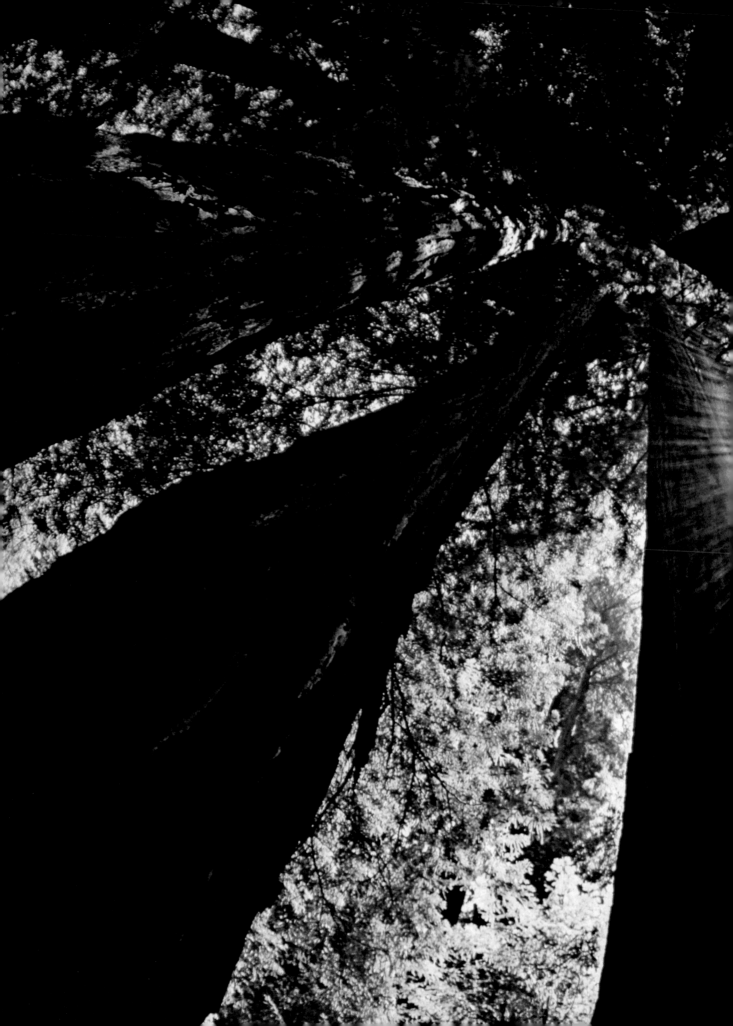

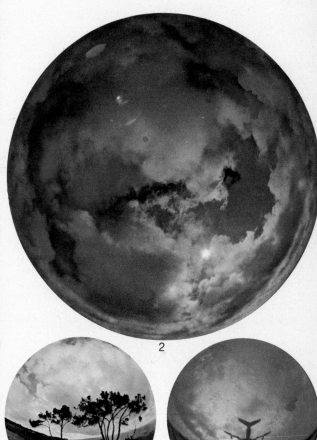

1. Photo of trees looks awesome indeed when shot with 17mm fisheye lens. Some wide-angle lenses are made optically so beautiful flare is possible when the lens is pointed directly at the sun or other point-source light.
2. An unusual photograph to be sure, but not too difficult to obtain if you have a fisheye lens and a good, steady tripod used to point the camera straight up. Then choose a day when the sky is full of fluffy, white clouds and make three exposures on the same frame using a red, blue and green filter. Wait a few minutes between each exposure for the wind to move the clouds. 3. A green filter was used here placed between the normal 50mm lens and a Spiratone fisheye conversion lens. Day was heavily overcast and lighting flat. 4. Other excellent fisheye subjects include large jets taking off or landing at a local airport with a color filter added for drama.

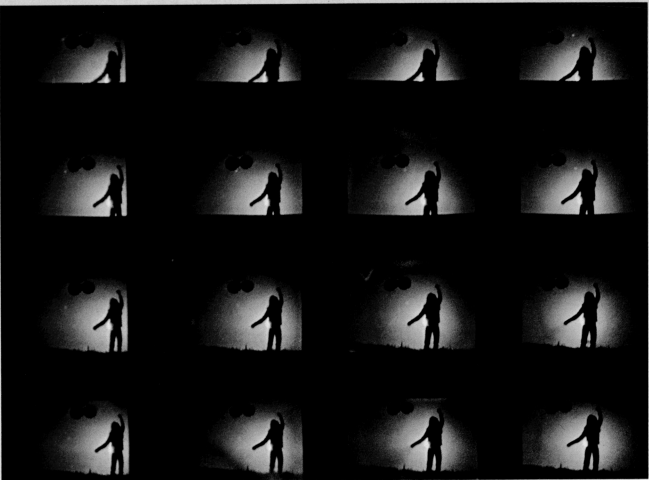

1. Silhouetted subjects work best with Edmund Scientific's Multi-Minifier, a transparent plastic sheet that produces up to 25 separate images on a single frame of film.

2. By using a +10 close-up lens on a bellows, a very soft diffused effect can be achieved that is unlike that of any normal diffusion lens. Obtain proper exposure with your behind-the-lens meter using the "stopped down" method—check owner's manual.

3. A high-powered telephoto mirror lens was used to create doughnut-like out-of-focus highlights on the shimmering water. Slip on orange gel behind the lens for overall color cast.

4. Sometimes things aren't what they appear to be and off-beat photos can result. This misty, foggy effect is actually smoke from a nearby fire—it's always wise to be ready for unusual picture opportunities.

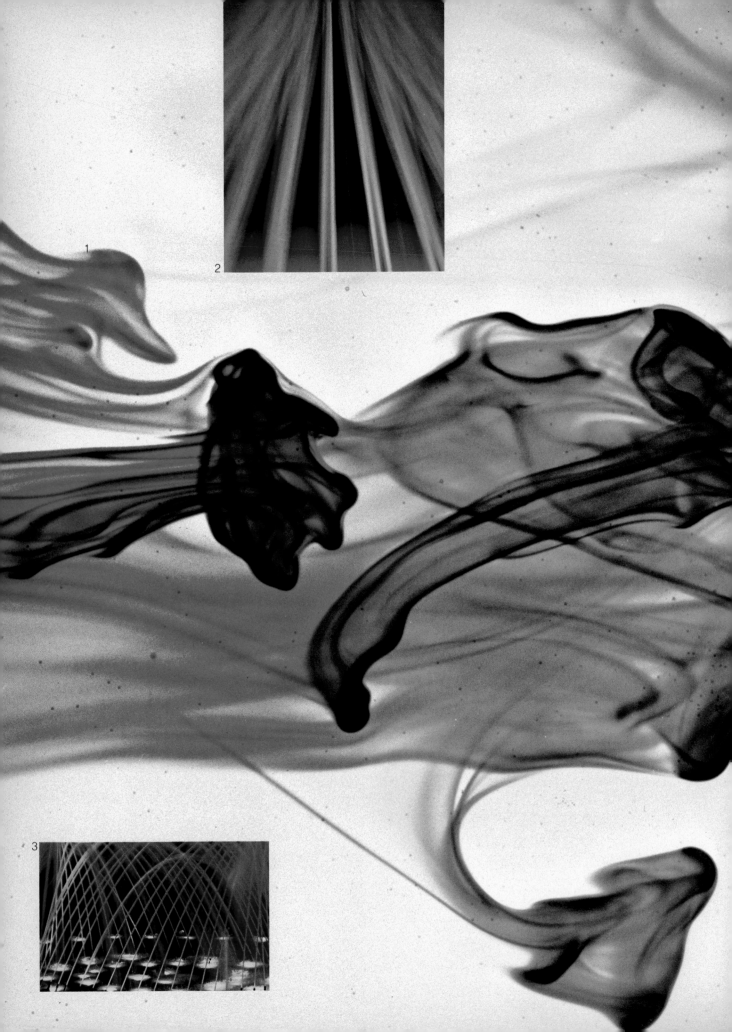

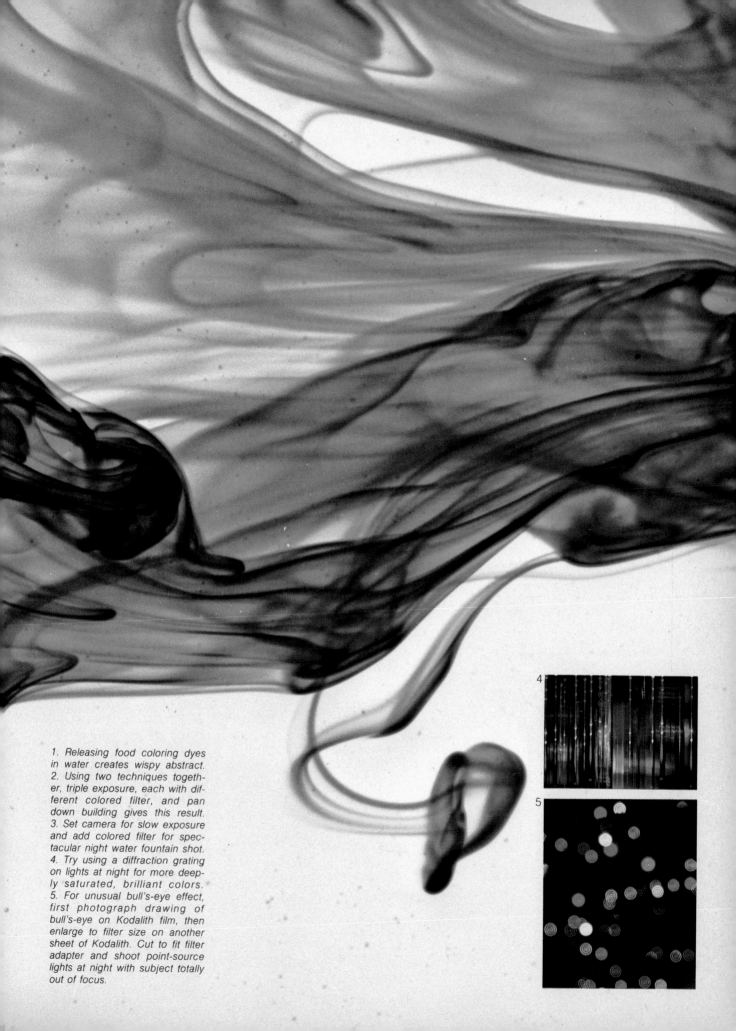

1. Releasing food coloring dyes in water creates wispy abstract.
2. Using two techniques together, triple exposure, each with different colored filter, and pan down building gives this result.
3. Set camera for slow exposure and add colored filter for spectacular night water fountain shot.
4. Try using a diffraction grating on lights at night for more deeply saturated, brilliant colors.
5. For unusual bull's-eye effect, first photograph drawing of bull's-eye on Kodalith film, then enlarge to filter size on another sheet of Kodalith. Cut to fit filter adapter and shoot point-source lights at night with subject totally out of focus.

fun with filters

For the average photographic enthusiast, the world of filters can prove a fascinating and/or costly adjunct to his hobby. I know photographers who buy a complete set of filters for each and every lens they own and end up never using them at all. As you've probably concluded, I'm heavily involved in the use of filters and make extensive use of each of the 50-odd I own. Fortunately for my pocketbook, I carefully selected each of my lenses from 24-200mm to accept the same filter size, so my filter collection involves no duplication to fit various lenses.

I would expect that most readers of this book are sufficiently well-versed in photography to have acquired at least a passing acquaintance with the filters commonly used with black-and-white emulsions—the yellow, green, red and orange often referred to by their former Wratten designations as K2, X1, A and G. In fact, these are used so often and are so accepted for their correction/contrast abilities that we overlook the fact that in a way, they are used for special effects. I won't go into the everyday use of filters for black-and-white photography except to give you a few tips on how you can produce extreme results with them—results that are somewhat beyond what can be considered normal.

We're all acquainted with the use of the K2 filter to bring out clouds by darkening the blue sky, but have 1

you tried for a night effect with a deep red filter and underexposure of a stop or two? Or perhaps you'd like a perfectly white backdrop when shooting outdoors with a model. Find a hill with open sky behind it and use a blue filter over the camera lens; this will cause the sky to go completely white instead of its normal medium gray. Filters also work nicely when you're shooting close-ups or portraits of people. An X1 (green) brings out a more swarthy appearance and masculine character in a man's face but heaven forbid if you use one to photograph your girlfriend; for her, a red filter is best since it causes the skin tones to lighten and is less likely to show blemishes. Don't forget to use a darker lipstick than normal, since her red lips will be lightened too.

Using these filters generally associated with black-and-white photography when the camera is loaded with color film can be quite effective. I've found that the blue, green and red filters work best when you're in a back-lighted situation since they have a nasty habit of blocking up detail when used with front lighting. Yellow and orange seem to work about the same regardless of the type of lighting. As you might expect, shooting through a green filter will give the picture an overall green tint, through a red filter, an overall red tint and so on, but there is a way to use these filters for most unusual effects.

THREE-FILTER TECHNIQUE

Try a triple exposure using the red, blue and green filters. Make one exposure with the red, one with the blue and one with the green without moving the camera from its tripod-mounted position. You see, these three colors cancel each other out (when the three additive primary colors overlap, white light, or in this case, natural color will result), so that when you use this technique, you'll get a perfectly normal color picture of everything in the scene *except* things that move, such as water, clouds, windblown trees, etc. The resulting picture becomes a semiabstract —something that's unusual,

2

different and yet the subject will still be recognizable. For example, suppose that you're at the beach photographing the waves hitting against rocks along the shoreline. Using the three-filter technique, the rocks will turn out their natural color, since they don't move. But the water, which *is* moving, takes on not only the red, blue and green filter colors, but their complementary colors as well.

You can work similar magic with white clouds against a blue sky. Use a wide-angle lens to include as much of the sky as possible, since you want a mixture of dark blue sky and fleecy white clouds. A polarizing filter will darken the sky and make the contrast between clouds and sky much greater. Use the polarizing filter for each exposure and make one shot each with the red, blue and green filters on the same frame of film. Wait a bit between each exposure to give the clouds a chance to move and the results will be breathtaking. You can work with this technique all day long and no two pictures will turn out exactly the same.

Night photography with the three-filter technique is another experience. Combine this with moving your camera between exposures of a stationary subject and you'll get three images, each with a different color. If they happen to overlap, secondary colors, yellow, cyan, magenta, etc. will be produced. Add the three-filter technique to the ideas in the chapter

on blurred images and it'll give everything an entirely different dimension.

Of course, you'll need a tripod that's rock-steady and a camera that will make multiple exposures without moving the film. To calculate exposure properly, take a meter reading of the scene and then open the lens up one additional f-stop—if the meter tells you 1/60 at f/11 is normal, then expose each of the three shots using 1/60 at f/8. Wherever there's motion to any great degree, it's best to use a shutter speed of 1/60 second or faster or you'll end up with little more than a fog of color.

If you happen to get hooked on this technique, you might be interested in using a Harris Shutter, and the August 1972 issue of *PhotoGraphic Magazine* included an excellent article on this device. The Harris Shutter employs the same principle of three filters, but they are mounted in a vertical frame one atop the other and the frame slides down in front of the lens during exposure. It makes three separate exposures and is about the only way to use the three-filter technique with subjects that move a great deal without trying to change filters. Detailed plans for building one can be found in Kodak's *Seventh Here's How Book* (Kodak Publication AE-90, 95 cents) at your local camera store or directly from Kodak.

NIGHT EFFECTS

I mentioned a polarizing

1. The only way to effectively darken the sky in color photography without affecting the other colors in the shot is with a polarizing filter. The polarizer has a factor of 2.5 and its effect in black-and-white work is shown here. 2. Another method of darkening the sky in black-and-white photography is with red filter.

filter in connection with adding contrast to the sky; like the filters used in black-and-white photography, this is commonly accepted for general usage in removing undesired reflections and darkening a blue sky. If you want an infrared sky effect without the usual ghostly foliage to really produce a believable night effect when shooting black-and-white, add the polarizer to the red filter and you'll be amazed at the results. But don't forget to compensate for *both* when calculating your exposure or you'll end up with a badly underexposed shot.

EMPHASIZING COLORS

Readers who have at least a passing acquaintance with color photography know that there are two basic types of filters commonly used, the color compensating or CC and the light balancing type. The CC filters are generally used to correct a color emulsion that's slightly off in color rendition but you can also work with them creatively to add an overall tint of color to a picture. They produce subtle color changes and can be used to strengthen a particular color in a scene. Suppose, for example, that your primary subject happens to be blue—add a blue CC filter and the color really pops out without altering the other colors in the picture very much. The red and magenta CC filters will pleasantly enhance skin tones when you're working with people while green and cyan tend to emphasize a

frail and sickly appearance.

Light balancing filters are exactly that—they are used to balance different types of lighting with the particular color emulsion you're using. In addition, filters such as the 81 and 82 series can be used to add warmer or cooler color qualities to a scene when you want to emphasize an effect that's already present or add an effect that isn't there.

For different effects with color film, I used to use theatrical gels sandwiched between pieces of optical glass, or gel holders, but the recent appearance of the Spiratone Vibracolor filters in purple, rose and aqua led me to toss the gels away. The purple and rose Vibracolor filters produce a deep coloration that many mistake as infrared color; the cyan is so strong that it makes all the colors fade together in a monotone effect that I don't particularly care for, but that's a personal opinion you might not share. Using a Vibracolor filter with your normal color emulsion will allow you to actually see what the colors are going to be and it's a great way to capture offbeat color without working with the unpredictable infrared film, when you hope for the best but never know exactly what effect has been achieved until it's processed.

For brilliant, saturated colors, you'll find that certain subjects and lighting conditions are better suited to the use of Vibracolor filters. Backlighted situations where

there's strong contrast—light against dark—work very well, and shiny metal or chrome will reproduce nicely with the Vibracolor and become very striking. The purple filter is so deep that you have to open up four full stops, but the colors it will produce are well worth the loss of light.

RAINBOW EFFECTS

Rainbow filters are some of the latest to hit the market and contain thousands of very fine and closely spaced parallel grooves per inch that diffract white light into a rainbow of colors. The filter you buy is actually a diffraction grating replica, or an exact reproduction made on acetate plastic from a master pattern that acts as (for purposes of simplification) a

prism that splits white light into red, green, blue and yellow. Before Spiratone marketed its Rainbow filter, the only way you could achieve the same effect was to buy a diffraction grating in acetate sheet form and cut it to size.

Diffraction gratings used as filters are available in two forms—circular and straight line. The circular ones produce a beautiful circle of colors with red on the outside, then a smaller ring of yellow followed by green and blue. To get the best effect, use a wide angle of about 24-35mm and point your lens into a very strong light source such as the sun or a spotlight; with a longer focal length, you'll be unable to bring the rainbow circle completely into the picture.

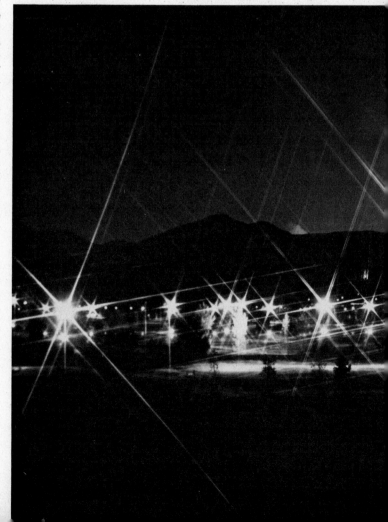

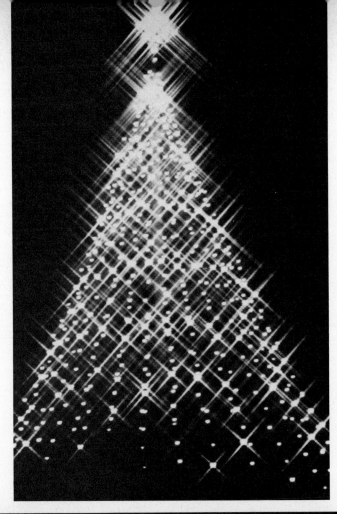

The straight line diffraction grating filter produces streaks of light similar to those of a cross-star filter, with colors in the streaks. This is the type offered by Spiratone as its Rainbow filter. Edmund Scientific offers both types—circular and straight line—but these are thin acetate sheets that must be cut down and placed between two pieces of optical glass before inserting into an adapter ring. If you really want to impress people, combine two or more layers of diffraction grating at different angles to each other and you'll find the results are truly spectacular.

CROSS-STAR FILTERS

Cross-star filters are one of the most common and popular types of special effect filters on the market today. Even cameramen on TV variety shows are using them to catch highlights surrounding performers to add a splash of starlit glitter to their acts. Cross-star filters are available from a wide variety of companies under several different names, but be sure you know exactly what type you want before you buy one or you may be sorely disappointed when the effect turns out to be different from that expected.

Cross-star filters are made with fine parallel lines in a grid pattern that intersect and diffract highlights or point source lights. For best results chose subjects with brilliant water highlights, reflections from bright materials such as aluminum foil or chrome, street or building lights at night, etc. Or you can light a model with catchlight reflections in her eyes and create a star effect in the eye (a common ploy in glamor photography).

One of the problems with selecting a cross-star filter is that there are numerous types with varying effects. The best approach to getting just the right one for your purposes is to take your SLR into the camera store and try several to find the one you like best before you buy.

Some combine a soft focus or diffusion effect that can drive you crazy if you're focusing for a sharp image. Others like the Kalcor Crystal (distributed by Kalt) produce a six-pointed star effect. This particular one is

Cross-star filters come in a variety of types and designs to achieve a virtually limitless range of effects using variations on a single theme. Point-source lights work best.

unique in that the flare effect is in color and similar to, although more subtle than, the effect of a diffraction grating. There is even one that combines two cross-star filters in a single mount, allowing you to rotate them in relation to each other to vary the effect from a perfect cross to a very slender X. The grid pattern filters are available in a variety of pattern sizes—1mm grids, 2mm grids, etc. The finer the grid, the more pronounced the effect; the coarser the grid, the more subtle and less distinct the effect becomes.

DIFFUSION

As a special effects technique, diffusion is popular but mastering it can be a disheartening process for many. All diffusion is not the same and it varies by more than just the degree of softness achieved. Some attempts at diffusion produce a flat, murky picture that is far from ideal. The best type produces a picture that retains the contrast while softening the image.

The standard commercial diffusion or soft-focus filter is usually colorless, transparent optical glass with concentric circles imprinted in it at equal distances. The soft effect is uniform over the entire picture area, but if you use too small a lens opening, it's possible to lose the entire effect. At the same time, if you open the lens too much, focusing may prove a problem. The best range in which to work is usually between f/4 and f/8,

Here's a trick that can work to your advantage as well as that of your model, and the lady in his life, when shooting men. An X1 (green) filter brings out the texture in his skin and gives him a more swarthy look.

but this is dependent somewhat upon the subject and your distance from it.

Do-it-yourselfery in the diffusion department requires more work and experimentation than using a standard diffusion filter, but the results are also more striking. Smearing Vaseline on a haze or skylight filter (never directly on the lens) will form a diffusion filter that allows greater control. The Vaseline can diffuse the edges of a photograph while retaining sharpness in the center of the picture. But since Vaseline tends to attract dust and dirt rather quickly, the best way to protect such an improvised filter is to face the Vaseline-smeared side toward the camera lens.

A single-element lens can also produce a lovely soft effect. A Plus 10 close-up lens or a *simple lens* available from Edmund Scientific can be attached to the camera by a bellows or extension tube. Since the lens has no diaphragm, exposure is controlled by shutter speeds alone. If you must go first-class, Spiratone offers its 100mm Portragon f/4 lens for use with 35mm SLR cameras via T adapters.

This is really nothing more than a single-element, uncorrected lens that produces a sharper image in the center than at the edges. It's not equipped with a diaphragm, since stopping the lens down would reduce much of the soft effect gained from the spherical aberration. While the f/4 opening is ideal for working indoors with artificial illumination, a slow film and/or neutral density filters will be necessary when using this lens outdoors in bright sunlight.

But for those who are really interested in diffusion, one of the most practical and versatile devices is not really a filter (or lens), and not even designed for camera use, but another device that I find works beautifully.

THE PIC-TROL

The Pic-Trol (by Arkay Corp.) is one of the most versatile diffusion devices I've ever used and it's about the same price as a diffusion filter. It was designed for use with an enlarger, but diffusing in the darkroom has its limitations, as you may be aware. Shadows tend to spread into the highlights when printing through a diffuser and this is not exactly desirable. In a moment of inspiration, I decided to adapt the Pic-Trol for camera use and see what would happen.

Attaching the Pic-Trol to my Nikon required a combination of three different adapter rings. Since the diameter of the device with its locking screws is too small for a Series 7 ring, I had to get a step-down ring from Series 7 to Series 6. A Series 6 adapter retaining ring then screwed onto the step-down ring and was easily held in place by the Pic-Trol's locking screws. To connect the step-down ring to my lens required a Tiffen 52-M7 adapter ring with a Series 7 female thread and a 52mm male thread. (If you never intend to use your Pic-Trol with an enlarger, you can turn it into a permanent camera lens attachment by epoxying onto the Pic-Trol a Series 7 adapter ring threaded to screw into your lens.) Depending upon your particular camera, you may or may not encounter similar attachment problems.

Once it's attached to the camera lens, you'll find the Pic-Trol to have two great advantages and two minor drawbacks. Its versatility in diffusion is a great asset, since you can obtain exactly the effect desired simply by rotating the outer ring. This not only saves a good deal of time when working but relieves you of carrying a dozen different diffusion filters of varying strengths.

As we know, not all diffusion devices produce the same effect. Some diffusion filters will not only soften the focus but will also reduce contrast considerably resulting in a very flat print. The Pic-Trol does a better job than the ordinary diffusion filter because of its ability to produce a print of acceptable contrast but soft rendition of the subject.

You can't use a normal or wide-angle lens with the Pic-Trol since it will vignette or darken the corners of the image. This is not as great a disadvantage as it might sound; when you're taking portraits, you'll most likely be working with a longer focal length lens anyway, and vignetting will cease to be a problem.

The device is also quite a bit larger than any diffusion filter and the front isn't threaded, so you can't use a lens shade unless you somehow manage to glue or tape one to the unit. But these are both minor problems, far outweighed by the quality of the results obtainable with the Pic-Trol.

Its use is simplicity in action. After mounting it on your lens, you'll notice that the movable ring has a series of numbers and letters around its perimeter. The numbers go from 1 through 10 and the letters from A to D. Since the transparent plastic blades completely cover the lens at the D setting, maximum diffusion can be obtained. I prefer to use settings between 8 and A for portraits.

The stronger the lighting and the closer you come to your subject, the more diffusion you'll need. Because each subject or lighting condition will vary, working with an SLR is recommended since it's a simple matter to see the amount of diffusion before you shoot. Just remember to view the image through the aperture you select for exposure or you'll have a completely false impression of the final result. I like to shoot with the lens wide open since the diffusion is spread more evenly over the entire image.

Before you rush out to get your own Pic-Trol, let me caution you about a minor problem I've discovered in using the device. When the image looks just the way I want it to, there's actually

too much diffusion apparent when the negative is enlarged or the transparency projected. Because of this, you should use a little less diffusion—one or two settings less than the one that looks just right.

To hold a sharp center with the edges diffused, stop the lens down to a smaller aperture. The more you stop down, the more pronounced this effect will become. Because of the unique qualities of the Pic-Trol, there are other effects possible, too. When shooting color, attach different colored gels to the blades using small pieces of double-sided cellophane tape, or you can paint the blades with transparent paint for a different effect.

Some films work better with diffusion techniques than others. Since contrast is lowered considerably when you diffuse the image, it's best to use a more contrasty film such as Kodachrome 64. When working in black-and-white, use a medium or slow-speed film such as Kodak Plus-X, Panatomic-X or Adox KB-14 for their inherently higher contrast.

Shooting into the light works well with diffusion since the light spreads into the shadows, giving a very soft, almost dreamy quality to the finished picture. Diffusion combined with backlighting will glamorize your subject when you don't want to show an abundance of detail. Under backlighted conditions, exposure will vary considerably according to the effect you want to

achieve. Take a reading from the background and the subject becomes a silhouette; take your reading from the subject itself and the background goes very light. You can obtain still another effect by slightly overexposing the subject and letting the background burn out completely. If you're not certain of the exact effect you want, bracket your exposures.

Subjects other than portraits turn out well when diffused. Full-length figure studies are interesting, but you won't need as much diffusion as with close-ups. Subjects that are very graphic with big masses of color and design readily lend themselves to diffusion techniques. These could be scenics such as a setting sun at the beach, a field of colorful flowers or even a forest with the light streaming through the trees. As with any other area of special effects, the possibilities are limited only by your imagination and curiosity. □

Not the most attractive piece of equipment you may own, but a very handy gadget when diffusion to varying degrees is the effect you're looking for.

4

1. This is an undiffused portrait taken with Nikon camera fitted with 105mm telephoto lens. Pic-Trol diffusion device was used at various settings in remaining shots in this series.

2. Here the Pic-Trol was set at No. 8 and the lens aperture at f/4. Note the difference between this and the undiffused portrait.

3. The lens aperture was set at f/4 and the Pic-Trol setting ring was placed in the A position. Notice the overall pleasing quality with this combination.

4. The Pic-Trol setting was left on the A position and the lens was stopped down to f/16. See how central sharpness was increased somewhat—but the overall effect was not destroyed.

multiple images

One of the most popular photographic special effects is the making of multiple images. If your involvement in your hobby goes back more than a few years, you can remember how many pictures used to be spoiled because of inadvertent double exposures. The majority of cameras today, however, have double exposure prevention built in and we knock ourselves out trying to defeat it in the name of art. There are several different ways in which multiple images can be easily created but probably the most popular with amateur photographers is the prism lens.

PRISM LENSES

Known also as multivision, multi-image, mirage and trick photography lenses, these attachments are available in a growing variety of types and each produces a different effect. Prism lenses come in a double ring mount with a handle on the front ring which allows you to alter freely the pattern or position of the images on the film, or even to rotate the prism during slow exposures. Some manufacturers use mounts that allow you to attach two or more prism lenses to each other while special adapter rings are available for those with nonthreaded front rings.

If you become interested in the type of effect produced by prism lenses, you can expect to spend a little money, since just one prism will have somewhat limited value because its effect will

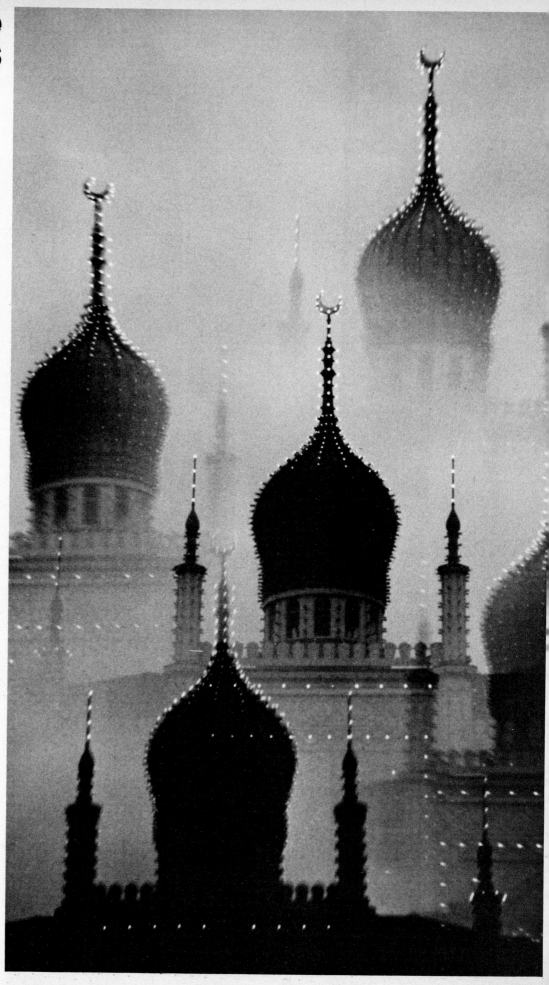

not prove suitable for every subject, and you'll soon tire of similar results with many prism pictures. In my experience, I've found the 3P (parallel) and 5S (section) prisms to be the most useful, partially because both have an image in the center as sharp as that of the primary lens. The outside images on these types suffer from diffraction to some degree and are thus not quite as sharp as the center section.

In order to see the effect you'll get, you'll have to use an SLR and you'll find that working with the normal lens is the most effective when using prism attachments. While it's possible to use a moderate wide angle, the images have a tendency to cluster at the center of the picture with the corners vignetting. The effect is just the opposite with telephoto lenses, since the images diverge from the center of the picture resulting in the cropping out of images on the side of the picture frame. I've found the use of a short zoom lens in the neighborhood of 43-86mm to be ideal when using prism lenses, since it provides a choice of focal length without vignetting or much cutoff of the outside images.

The lens opening used will also have a considerable effect on the multiple images created. With the lens stopped all the way down, the images separate and their dividing lines become much more distinct and noticeable. With the 5S and 6S prisms, the outside images

also tend to become a little sharper. Working with the maximum aperture of your prime lens, the images blend together with no noticeable dividing line but at the same time, there's a loss of contrast and saturation. My personal preference is to work in the neighborhood of f/5.6 to f/8 since it gives the type of image *mix* that I like best. To determine the effect that you prefer, I suggest you rely upon the depth of field preview feature on your camera; this will let you see exactly what happens at each aperture.

When working with the prism lens attachments, it's best to keep your subject simple and against a plain background whenever possible to prevent the picture

from becoming too confusing and cluttered. Silhouettes are excellent subjects since they are usually very graphic and bold in nature. A model against a seamless paper background, or in an open field is ideal for prism shots. Don't overlook the sky as a background, either by shooting from a low camera angle or from a hilltop. You'll also find that working at night with a prism lens produces excellent results, since you have darkness to isolate your subject.

Until very recently, I cut pieces of theatrical gels to fit each facet of the prism, attached them with very small pieces of double-sided cellophane tape and shot color film to produce different colors in each image. At least

one supplier of lens attachments has caught onto the idea and the new Izumar prism, available from La-Grange Inc., provides similar benefits without all the fuss and bother of cutting and taping gels. The Izumar 6S color prism is exactly like standard 6S prisms, but it has a concentric color spectrum ranging from red to blue incorporated in the glass. There are no clear and no opaque segments but simply a blending of color in the glass. The effects are spectacular, but as you might imagine, so is the price.

The possibilities with prism lenses are limitless and will continue to be so as manufacturers are constantly producing new designs and configurations. But remem-

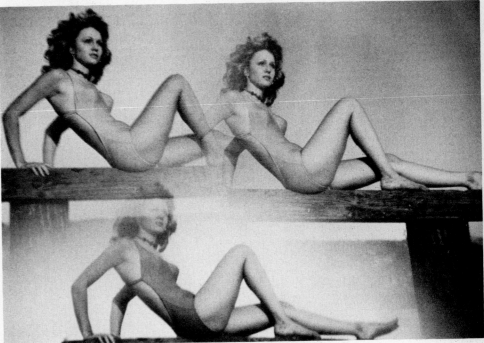

Though some may think of prism filters as mere gimmicks, you will find that, used judiciously, they can add a whole new dimension to otherwise stale, ho hum photography. Night and twilight pictures lend themselves particularly well to the prism technique. In the photo at left a five-section prism was used, while a three-section prism provided result in photo above. Since there are about seven different types of prisms available, used creatively, results can run the gamut.

ber, select your prism according to the type of subject you're most likely to shoot and don't overwork the technique. Use it when you want to add an effect to your picture that's otherwise unobtainable, and shoot both with and without the prism. Who knows—you might find that you prefer the straight shot after all.

MIRRORS

Another technique to produce multiple images is to work with mirrors. One of the most common effects that can be produced is quite similar to the one obtained when using a 6P prism lens. Although the mirrors require more time and patience to set up and use than does the prism lens, you also have considerably more control over the pattern of repeated images, in addition to better sharpness, and for serious workers, the results are well worth the extra effort.

While you *can* use any mirror, you should realize that mirrors are made in two different ways and that one type works better than the other. A front-surface mirror has the aluminized coating right on the top surface of the glass while ordinary mirrors of the five-and-dime variety use an aluminized coating on the back of the glass. While the front-surface mirror is considerably more expensive and tends to scratch very easily (requiring much care in handling), there are no secondary ghost images —the primary problem when

ordinary mirrors are used for photographic purposes.

Everything you need to get started in producing mirror effects is obtainable in the Trick Photography Kit offered by Edmund Scientific Company. Once you've exhausted the possibilities of double image variations and kaleidoscope effects with this kit, you might want to add another variety of front-surface mirror material to your special effects bag. Locate a retail store that handles mirrors and have someone there cut a front-surfaced mirror into strips for you— about one dozen 1x12-inch strips plus an extra piece 3 to 5 inches wide and 12 inches long should do nicely. Then tape the pieces on a 12x17-inch sheet of canvas-like fabric using double-sided tape. This will provide unlimited flexibility in positioning the mirrors and the effects obtainable will keep you occupied for some time.

CHROME MYLAR

Chrome Mylar is available from most commercial plastic suppliers and can be used to produce fascinating departures from the mirror technique. It can be used in sheets just as you'd use a mirror, or with care and patience, it can be cut into strips to make a device similar to the flexible mirror described above. Either way, the end results won't be exactly like those obtained with mirrors since Mylar introduces an element of distortion to a degree approaching fantasy.

PLASTIC LENS SHEET

Other variations in multiple images can be obtained by using a plastic lens sheet in front of your camera lens. Edmund Scientific also offers one called the Multi-Minifier, a transparent 8¾x10-inch plastic sheet containing 25 separate Fresnel lenses moulded in it. Each lens on the sheet measures 1 3/16x 1 9/16 inches and is negative (thinner at the center than at the edges), thus it encompasses a larger field of view than would a plain window of the same size.

Mounting the plastic lens sheet in a carboard frame is a good idea; this will not only protect it from possible damage but also lets you clip it in place when working indoors or on location. You'll find it almost impossible to use outdoors on windy days, since it's very difficult to control under these conditions. Since you're focusing on a flat plane and rather close to it, a macro lens will make everything a little easier and more accurate, but if you don't happen to have one, just take a little more time and effort to make sure you focus correctly and the camera's normal lens will be adequate.

The first time you use a plastic lens sheet, you'll discover that the lenses on the outside of the sheet don't cover the same field of view as the ones in the center. If this proves to be objectionable for your purposes, the effect can be minimized by keeping your subject farther

In photo at left five- and three-section prisms were combined to make this unusual portrait. During ¼-second exposure, the 5S prism was rotated for the blur effect leaving the center images sharp. Top photo shows much sharper images can be obtained with mirrors than are possible with prism filters.

Adjusting the canvas slightly to move the mirror planes makes possible a wide variety of images. In photo above a dozen strips of mirror material were taped to a black canvas-like backing. Since the results are flexible, the strips can be moved in relation to each other and clipped to a light stand.

away from the lens sheet, to bring most or all of the subject in view of all the lenses. Remember that you'll be taking in 25 images on a single frame of film so all of them will be rather small. This should immediately suggest to you that subjects chosen for use with the plastic lens sheet should be bold and graphic instead of those with lots of detail in them. Whenever possible, you'll find the use of a plain background tends to enhance the effect.

For the inventive, there's an alternative approach to the plastic lens sheet that proves to be just as effective; it works in about the same manner, and since you can adapt it to fit directly onto your camera lens, it's easier to work with. All you need is an ordinary meter grid used on reflected-light exposure meters. Mine came from a discarded meter that was tucked away in a corner of my camera bag.

Using a piece of light-weight black cardboard (any poster board will work) with a hole cut in the center, I glued the meter grid over the hole and cut the cardboard to fit into a Series 7 adapter ring. Coupling a pair of extension tubes to the front of my 55mm macro lens, I fitted the adapter ring over the end of the extension tubes. This put the meter grid out where I can focus on it— about three inches from the lens. A combination of adapter rings and extension tubes should do the same for you, depending upon the particular camera and lens.

you're using.

As with the plastic lens sheet, you should work with subjects that are very bold and graphic, and for maximum sharpness, close your lens down as much as possible. Compared to the lens sheet, the meter grid is really portable, can be used regardless of weather conditions and if you're the type of photographer who likes to move fast, this variation will fit right in with your style.

MULTIPLE EXPOSURES

As I mentioned at the beginning of this chapter, the old problem of double exposures was once the bane of both amateur and professional alike, causing camera manufacturers to incorporate double-exposure prevention devices in their products by coupling film transport with shutter cocking. Today, the situation has reversed itself 180 degrees and the creative photographer finds this device prevents him from carrying out many great ideas—only now we refer to the technique as *multiple* instead of *double* exposure.

If your camera has a provision for making multiple exposures easily, you can create multi-images simply by making two or more exposures on the same frame of film. If you're in the Nikon F2 or Minolta XK class, you'll have no difficulty since these top-of-the-line cameras have a multiple exposure provision that unlocks the film transport while allowing you to recock the shutter— and the film will not move

out of register. Many other cameras can be modified by a qualified camera serviceman (if interested, you might try Camera Service Center, Culver City, California), but you might not want to spend the $75-100 necessary just to make an occasional double or triple exposure.

If your 35mm camera doesn't have multiple exposure provision and modification is economically out of the question, then try making multiple exposures in the following manner. Shoot your first exposure, then tighten the film by turning the rewind knob and holding it. Depress the film rewind release button and advance the rapid wind lever. This cocks the shutter without advancing the film. Still holding the rewind knob to keep

tension on the film, release the shutter to make the second exposure. Then make one blank exposure before taking another picture—this avoids any chance of overlapping. The only problem with this technique is that registration of the second exposure may not be exact, since there's no way to tell until you develop the film whether or not the tension applied on the film by holding the rewind knob kept the film from moving ever so slightly. But depending upon your subject, a slight movement may have little or no effect—a multiple exposure portrait photographed against a black background is a good example.

In addition to the desirability of having a camera with provision for multiple expo-

Meter grid technique above produces honeycomb pattern. Since photos made this way are small and not particularly sharp, choose simple and graphic rather than busy subjects. Twelve exposures were used to make night shot of Los Angeles skyline. The camera was moved slightly between each exposure.

sures, you should also have a good sturdy tripod since you must be able to completely control camera movement between exposures. You can move the camera in any direction: vertically, horizontally or on a diagonal. You can also vary the number of exposures; I plan my shots to stay within three to seven exposures because going beyond this number tends to become a bit impractical. If you're using a 35mm camera without the multiple exposure provision and following the technique outlined above, you'll find it best to keep the number of exposures on the lower side, since keeping tension on the film while advancing the rapid wind lever and repositioning the camera if necessary can be a tiring process.

Since each additional exposure introduces more light to the film, you must stop your lens down one f-stop every time you double the exposure in order to compensate. This means that an ordinary double exposure would be made at one f-stop less than the meter indicates. If you make three exposures on the same frame of film, each would be shot at 1½ stops less than normal, four exposures require stopping down two stops, etc. If you wish to maintain one particular f-stop for a certain effect, you can, of course, adjust the shutter speed to the same degree rather than stopping down.

Almost any lens will work with the multiple exposure technique, but I've found it more difficult to control telephoto lenses to make fine movements whenever you have to move the camera between exposures. If you use a Canon or Nikon, one of the easiest lenses to use for multiple exposures is the perspective control type. While these are primarily used for architectural photography and other instances when you find it necessary to control perspective, you can manipulate the lens without moving the camera and control the amount of space between the images with precision.

If you have access to a studio and one of the rapid repeating strobes, you can make multiple exposures simply by firing the strobe. Open the shutter on bulb and ask the model to walk or run in front of the camera as the strobe fires its eight or so flashes per second. Or, try having the model hold one pose for a second or two and pan the camera while the light fires. Actually, this is an ideal method of making multiple exposures of people since they don't easily hold a single pose long enough to make seven or eight exposures, recocking the shutter between each.

PATTERN MULTIPLES

Readers who are darkroom buffs are already acquainted with multiple exposures made under the enlarger but for those not familiar with what can be done under the red light, here's a brief sampling. One of the techniques possible is to

make pattern multiples from a single negative by multi-printing. This can be done in a couple of different ways, the simplest of which is to make a series of prints that are identical in size and density, flopping the negative each time so the same corner of the picture can be placed in the center. While you can make any number of prints as long as they're in multiples of four, I suggest you start working with this technique making only four prints at a time until you've practiced a bit.

As an example, suppose you have a negative of a building in which the base of the building occupies the lower left side of the picture. This lower left corner on each of the four prints would be butted together in the center to form your pattern design. Having a part of your subject occupy a corner of the picture is very important, since the corners of the subject should meet in the center. This means making full bleed prints without borders.

When the prints are dry, mount them on a dark gray or black board (unless the picture and pattern are to be very high-key) since this will help to hide the hairlike border that separates the four prints. To get the bottom

This high-contrast bridge shot makes a unique pattern multiple. When shooting pictures with this technique in mind, remember to have something coming out of the corner of the picture that will meet in the center to form the pattern design.

portion of the pattern, you simply mount two of the four pictures upside down. When the finished pattern multiple is dry, you can then rephotograph it (watch the lighting to make sure it's even and flat) and you'll have a negative that will allow you to make prints of the pattern to any size desired.

A similar thing can be done with 4x5-inch color transparencies (anything smaller is not large enough for viewing and is too small to work with) by shooting four identical shots of a subject. Take the three extra shots and turn them over and upside down so the corners butt in the center. Naturally, you won't mount the color transparencies on a board, but you can tape the edges on a light box and recopy to produce a single transparency containing all four images.

An entire repetoire of multiple printing techniques is described in *Petersen's Guide to Creative Darkroom Techniques,* which is a natural lead-in to the section on producing special effects under the safelight. But we've avoided the usual methods and materials to concentrate on a few tricks not mentioned in *Creative Darkroom Techniques.* If you're not up-to-date with what's going on in the darkroom these days, pick up a copy; in the meantime, turn to the darkroom chapter for a peek at some of the things that are breathing new life into an old art these days. □

darkroom effects

If your negative/slide file were large enough, you could create many of the special effects in the darkroom since there are certainly enough different techniques and combinations to keep you busy for years. To this point, we've talked about effects created when you photograph the subject, but now it's time to take a brief look at a few of the possibilities with pictures you already have on hand. Most of us take very few pictures that can't be improved to some extent after the fact and the handful of techniques that we have the time and space to cover here should provide sufficient food for thought to keep you active under the red light for many hours.

You've probably heard a lot about *op art* in the last few years, and it's finally found its way into the darkroom in the form of moiré patterns. When two repetitive designs are overlapped in close alignment to each other, we call it op art and when the lines almost superimpose, we have created a moire. The fastest way to get into the swing of op art/moiré patterns is to obtain the set of 16 moirés sold by Edmund Scientific. This contains a set of patterns on .020-inch clear vinyl and an identical set on Kromecoat paper.

Use the Kromecoat paper patterns to make additional copies on Kodalith film. This will give you control over the size of your pattern effect. You can make patterns small enough to sandwich with a 35mm color slide or large enough to place on top of an 11x14- or 16x20-inch piece of enlarging paper. Using the pattern on top of enlarging paper provides control over the amount of the pattern you want to work with. For a subtle effect with the moiré pattern showing just a little, make a partial exposure of the paper with the pattern in place, then remove it and continue the exposure without it. When the moiré pattern is sandwiched with the negative for printing, you don't have this degree of control.

There are other advantages to making extra sets on Kodalith film. You can make as many as you want or need. If you plan to sandwich the patterns with your color slides, you'll require a constant supply of them. Extra copies will also give you a set of both negative and positive patterns. Using one of each produces some very interesting bas-relief effects.

Spend an hour or two just playing around with the set of patterns—moving them around in relation to each other, trying different combinations, etc. This will give you a good idea of the many hundreds of different moirés that can be created. Although most photographers use them primarily with a color slide or negative, you might spend some time just making abstractions using only the moiré patterns. This exercise will help you fit the right pattern to the right subject, since you'll find that certain types of patterns work better than others.

I've found the radial line moiré to work well any time I want to suggest rays of sunshine while the converging square pattern adds punch to a picture of a long hallway and similar shots where distance and perspective are important. The concentric circle moiré suggests a target or bull's-eye and helps to lead the viewer's eye to a specific area in the picture. Patterns with wavy lines suggest peace and tranquility when used horizontally with appropriate subjects such as fields of waving grass or large expanses of water.

TEXTURE SCREENS

From op art, you will find the transition to texture screens a natural one. While

A moiré pattern of concentric circles was used above to reinforce the round light patterns created by use of a circular diffraction grating. Op art and high contrast often go hand-in-hand as shown in photo at right. Very bold and graphic, each technique complements the other. This picture was created by laying a pattern screen on top of the enlarging paper and removing it midway in the exposure.

texture screens have been around for quite a long time, someone is always coming up with a new use and so they continue to be popular methods of producing special effects in the darkroom. You can make or buy a wide variety of screens to fit the various needs you anticipate. Again, the key to success with texture screens is experimentation. Since they lower the contrast somewhat, it's best to use a paper one grade higher than normal when enlarging. By using a negative and a positive texture screen of the same design together but slightly off-register, you'll obtain a bas-relief effect. Or, try using a coarse screen and throwing it out of focus a bit. Just remember that the basic reason for using a texture screen is to enhance the overall mood and effect of your subject, although there are times when you'll find it handy to camouflage a scratched negative, to soften the harsh facial lines in pictures of older people, or even to provide extra detail and texture in the dark areas of a print made from an underexposed negative.

A variation on the texture screen effect, the use of textured glass produces fascinating pictures, but the glass is somewhat difficult to obtain, even in large cities such as Los Angeles or New York. Most glass shops carry only one or two patterns on hand since the demand for it is not great, and this type of glass is delivered to retail glass stores in sheets up to

12 feet in length and several feet wide.

Hammered, doublex, flax, velvex, ribbed, muralex and skytex are a few of the dozen or so types of pattern glass available, and the fastest way to get into the textured glass business is to write American St. Gobain Corporation in Kingsport, Tennessee, for a catalog and price list. This will give you an idea of the different types of pattern glass they sell and then you can either search local glass shops or order directly from them. A 20x24-inch piece should cost somewhere between $5 and $7.50, but if the shop has to special order it for you cut to size, it could run as high as $20.

If you plan to make prints no larger than, say, 8x10 or 11x14 inches, it's best to have your glass cut down to that particular size, since there's little sense in paying for more than you plan to use. For safety in handling, have the corners rounded if possible and then put masking tape around the edges to prevent the possibility of cutting yourself while working in the darkroom.

When working with textured glass, the enlarger baseboard becomes your easel. Compose and focus on a piece of white paper and tape two thin pieces of cardboard at one of its corners to use as a guide for positioning the enlarging paper. Replace the focusing paper with a sheet of enlarging paper and lay the textured glass on top. Make a test strip to determine both correct exposure and contrast, since you'll discover that exposing through the glass will lower the contrast of the print—some patterns lower it more than others.

You can alter the pattern by flipping the glass over or by raising it slightly above the paper. Removing the glass after making a partial exposure and then continuing the exposure without it will produce a softer pattern. As with moiré patterns and texture screens, it's important to select the correct glass texture, one whose design or pattern lends itself to the subject in your negative, since some textures are very coarse and tend to blot out detail in subjects that are not bold and graphic.

LIQUID EMULSION

If you're interested in printing photos on things other than paper, there's a way to go for you, too. In fact, there's a kit available that allows you to make pictures on almost anything—your morning egg, your bar glasses or racing helmet. In essence, the Sensitiz-Sur Kit by Diversy Creation Corporation allows you to coat almost any object with a light-sensitive emulsion and then print your picture on it.

After reading the instruction booklet included with the kit (and digesting the information therein), your first major decision is just which negative to print on what object. For openers, you'll do well to practice on the sample objects supplied with the

kit. The first step is to prepare the surface to be sensitized. Since the surface must be absolutely clean, wash it with hot water and washing soda (the soda will not leave a greasy film) and dry with a lint-free cloth (lint is as objectionable as grease). Then apply the photo-base supplied with the kit. Use a soft-bristle brush when applying it on all glass, ceramic and anodized aluminum surfaces.

With all other porous and nonporous materials, you'll need to apply clear polyurethane varnish to the surface. For objects very dark or black in color, use a flat-white latex paint to produce a white surface to print on. There's no need to use the photo-base when you use the white paint, since you can put the emulsion directly onto the painted surface. A word of caution—it's sometimes difficult to see just where the coating is when applying the clear photo-base to surfaces like glass, so it's best to work under a spotlight, in the sun or under a high-intensity desk lamp. Once the surface has been prepared, place the object in a dust-free area and let it dry overnight.

Applying the light-sensitive emulsion must be done under a safelight. A gel in its normal state, the Sensitiz-Sur emulsion must be transformed into a liquid before application. Place the bottle in a pan of warm water between 100 and 110°F for approximately 15 minutes— don't let the temperature go above 115° or you'll fog the emulsion. Since the emulsion comes in a clear white bottle, it must be heated with the lights off, but here's a neat trick—spray the bottle with several coats of black paint. After it dries, the only time you'll have to work under a safelight is when actually applying the emulsion to the objects you plan to print on. You can also store the bottle without having to wrap it in black paper each time. After 15 minutes in the warm water, the emulsion should be liquid enough to coat the object.

Coating can be done in three different ways: spray it on with the Prevel power unit included in the kit, use a brush and paint it on, or dip the object into a container of emulsion. I've found the spray method works best since you get an even coat with a single spray. If you paint the emulsion on with a brush, you have to put on two coats, a time-consuming process since it must dry overnight between coatings. The dipping method has one major drawback—you must have a very small object or a lot of emulsion because you can't dip an eight-inch plate into six ounces of the stuff. If you spray, work in a well-ventilated room because of the fumes.

You'll find that some objects are more difficult than others to coat. Flat surfaces such as plates and pieces of wood or metal are the easiest to work with; objects like eggs have a tendency to roll about, making the process a bit more difficult. Use some pieces of cardboard and three push-pins on each side to hold an egg in place. And what do you do with the egg, plate or whatever while waiting for it to dry? Leaving it in the darkroom sounds like a logical solution, but unless you have a light-trap entrance, you're stuck in there with it.

Obviously, the answer is a light-tight box or drawer the object can be placed in to dry once you finish the coating process. I use my negative-drying cabinet (which is also light proof) for storage. After coating all your objects, make some test strips on 5 mil white plastic, which is available wherever plastics are sold. This plastic is flexible and

A commercial texture screen was used, left, for 70% of the exposure. To compensate for loss of contrast when using the screen, Agfa No. 6 paper was used. Very bold and graphic subjects with little or no detail such as photo at right can be used with a coarser screen and still read well.

can be wrapped around round objects when making your exposures under the enlarger. Cut the sheets down to 4x5-inch size, coat about a dozen and store in empty printing paper boxes.

Whenever possible, you should have a stand-in for the object you're working with. If you're going to print on an egg, have another one handy that can be used for composing and focusing the image. Place the unsensitized stand-in egg under the enlarger and project the image onto it. Since an egg is rather small, you'll probably have to use a longer-than-normal enlarging lens to bring the image down small enough—an extension bellows on your enlarger can be most useful here. Since the emulsion is very slow, it's best to work with as powerful an enlarging lamp as your enlarger will stand.

Once you have the image composed and focused, you should stop the lens down as far as it will go to keep the sides of the egg in focus. Cut a 4x5-inch test strip in half, wrap it around the egg and make a test exposure. Develop as you would regular enlarging paper and transfer first to a water bath (don't use short-stop) and then into fresh hypo. After you have determined the correct exposure, substitute the sensitized egg under the enlarger and turn on the enlarger lamp with the red filter in place. Position the image on the egg, switch off the lamp, remove the red filter and make your exposure.

When developing the egg, be careful not to let the emulsion touch the developing tray, since it is very delicate when wet and will chip easily if it comes in contact with another object. When working with objects like eggs and glasses, I've found that large coffee cans work well to hold the chemicals. Let the object stay in the hypo for 10 minutes, then carefully move it into the wash. I place it in a small aquarium fishnet and set it into the top of my film washer. Flat objects are easier to handle and can be washed in a tray. To prevent streaking, use a wetting agent such as Photo-Flo. After 15 to 20 minutes in the wash, you can let the object drip dry. If the final result isn't what you expected, you can wash the picture off with a solution of hot water and washing soda, recoat and try again.

The red, blue and yellow colors that come with the kit are used to tint the black-and-white print. These may be mixed to get other colors, and they may be reused. Diluting the colors will lighten them and you can tint the image with one overall color or tint various parts of the image with different colors. Single-color tinting is as easy as toning a print; multiple-color tinting is more of a challenge and takes some practice.

For overall tinting, place the object in a tray or container of the color you want and leave it for 30 to 180 seconds—time determines the richness of the final color. Only the areas covered by emulsion will be tinted. When the color is intense enough, remove the object and wash for 10 minutes in cool water, then let it dry. Pour the tint back into the bottle for reuse.

For multiple or selective tinting, you'll need an artist's paint brush (No. 1 works well) to apply the color into various areas of the black-and-white image. If you're working with a large object and a very graphic image, you can also mask off portions with masking tape. For a splash-on effect, pour different tints on top of each other. Make up some test strips and practice tinting on those before applying it to the real thing.

Since dishes, drinking glasses and the like undergo quite a punishment by repeated washings, it's essential to apply a preservative to the finished object, preferably a clear or matte acrylic spray, which can be purchased at any hardware or paint store. Let it dry completely and your handiwork is ready for use. The possibilities with this print-on-anything kit are endless; you can make a set of personalized china, art objects, or even try your hand at printing on fabrics. The process sounds rather involved at first, but after you have the routine down, it becomes as easy as regular printing.

COLOR-KEY

The 3M Color-Key Contact Imaging Material makes it possible to get a finished result from a black-and-white negative in 10 minutes. Designed originally for printers, Color-Key has been discovered by photographers seeking a quick and easy posterization effect but is still sold mainly through graphic-art stores. It's basically an ink-pigmented coating sensitive to ultraviolet light and applied on a super-thin (.002-inch) clear polyester base. Since Color-Key material is quite insensitive to ordinary room light, you can work without a darkroom.

Color-Key material is sold in various sizes but 10x12 inches is standard and a good one for those new to the process, since it can be cut into six 4x5s, or two 4x5s and one 8x10. The material is sold in two ways—a Rainbow Pack of 25 sheets or Pantone Packets of five sheets each. The latter are available in 48 transparent colors keyed to the Pantone Matching System, a standard trademark for color reproduction and color-reproduction materials belonging to Pantone, Inc. The Pantone Packets are more expensive on a per sheet basis but you can order the exact colors you want while the Rainbow Pack includes six sheets of transparent black, which you will probably never use.

When combining portraits with texture screens in the darkroom, subtlety must always be kept in mind. Enhancement of the original photograph can result if care is taken with the selection of the screen in photo at left. Texture glass, used, right, gives similar results to those of texture screens. This works well when subject is in silhouette as shown.

For posterization effects with Color-Key material, determine the size print you want. Since Color-Key material has to be contact-printed under a very bright light, you'll have to use an 8x10-inch negative if you want an 8x10-inch Color-Key sheet or cell. You'll work with high-contrast negatives, which can be made from either a color slide or a black-and-white negative, but you need a set of three positives and three negatives. It's best to make three positives of different densities (heavy, medium and light) from your negative so you'll have more control over the final result. Contact print each of the three positives on 4x5-inch Kodalith film and you'll have the set of three positives and three negatives to work with.

Now you're ready to start working with the Color-Key sheets to make what we call a cell. Most of the time, you'll be using two or three colors—and the ones you select are entirely up to you. There are no rules that tell which colors to use or not to use; this is in the realm of the creative/artistic, so it's really up to your own personal taste, which makes it much more fun. But a good starting point would be the three basic subtractive colors: magenta, cyan and yellow. If you want to exploit the system's maximum possibilities, make all six negatives and positives with all three colors and you'll end up with 18 colored cells to play with on the light box. If that sounds too complex,

contact print one negative and positive set with magenta, another set with yellow and the remaining pair with cyan. It all depends upon how involved you want to get with the process.

Once you've decided on the colors you're going to use, place the sheet of Color-Key material emulsion-side-down in your contact printing frame. If the bottom of the frame isn't black, use a black piece of paper and place it on the bottom. Position the high-contrast negative or positive emulsion-side-down on top of the Color-Key material. Close the frame (making sure you have good contact) and you're ready to expose.

Position a 500-watt photo-flood bulb about 18 inches above the contact frame. The exposure should range from 45 seconds to about two minutes. After exposing the Color-Key material, take it out of the contact frame and place it emulsion-side-up for development. Pour some of the Negative Acting Color-Key Developer over the material and with a Webril Pad wrapped around a special Color-Key Developing Block, begin rubbing the unexposed emulsion off the Color-Key material. You can also use an old spray bottle to apply the developer; this uses less solution and works equally well. After the unexposed emulsion is removed (which takes only a few seconds), wash it down with tap water for a few seconds, then squeegee the water off and place the cell between

two blotters to dry. The only thing remaining is to sandwich the different color sheets together.

The end result of this process will consist of two or more transparencies (Color-Key only or Color-Key and original slide) sandwiched together, either in register or out of register for a bas-relief effect. By experimenta-

tion, you'll discover that some pictures look best in exact register while others come out better off-register. Personal taste has a lot to do with it.

The amount and direction of off-register images will make a big difference. You may use four or five cells sandwiched together, all in register except for one or

1

Color-Key material is shown being exposed in a contact printing frame to incandescent light. Length of exposure depends on intensity and distance of light but should be completed within 45-120 seconds. 2. Color-Key developer is poured over the treated sheets. If you apply the developer with spray bottle, you'll use less.

3. The unhardened Color-Key is wiped away using a Webril pad and a Color-Key block. 4. Wash the processed Color-Key cell clean. Care should be taken not to scratch the surface while you're working on it. 5. Place the finished Color-Key cells on a blotter sheet to dry. Then you can set about sandwiching them on light box.

2

3

4

two, and you can throw them off-register vertically, horizontally or on a diagonal. The combinations possible are many and varied and you'll want to take a bit of time to explore just which effects work best.

Once you have several sheets of Color-Key sandwiched together, what do you do next? If you've made

is also good if you work with 2¼. Your light source for copying can be either electronic flash or fluorescent light such as those found in transparency viewers. In my own darkroom, I have a piece of 8x10-inch glass set into the work table, with a 40-watt bulb underneath. When I work with Color-Key material, I just replace the

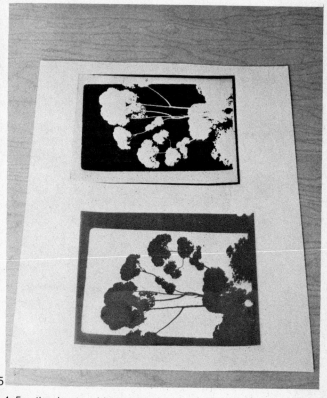

5

4x5s, they're too big to project, too small to display and you'll need to preserve the way in which you have them registered. The answer is to copy them on a fine-grain color film like Kodachrome 25. Ektachrome Professional

bulb with my portable flash.

We've covered only a few of the many ways in which you can create your own special effects in the darkroom but there should be enough food for many hours of creative thought. □

adventure with the abstract

To this point, we've talked primarily about creating special effects that enhance reality, both in the camera and under the darkroom safelight. But the creative photographer should not overlook the potential of pure abstractions and so it is fitting to close out the book with a consideration of some of the ways you can work with them. While there are numerous techniques that can be used to produce pure abstractions, none have more possibilities or are easier to create than physiograms, commonly known as penlight patterns—designs made by time exposures and influenced by gravity.

The abstract patterns of light are made by attaching a swinging pendulum light source (such as a penlight) to the ceiling with a thin wire or string. Positioned beneath the light, the camera is placed face-up on the floor or attached to a low tabletop tripod. Once the penlight is swung into motion, the shutter is opened and the pattern of light created by the moving penlight is recorded on film. The different patterns and designs that the light can take are unlimited and highly effective, especially when using color film with a variety of colored filters.

Perhaps the most difficult part of making physiograms is the setup and testing. While penlights can be used as the point source light, many can be improved by making a mask of black cardboard with a pinhole in the center and taping it over 1

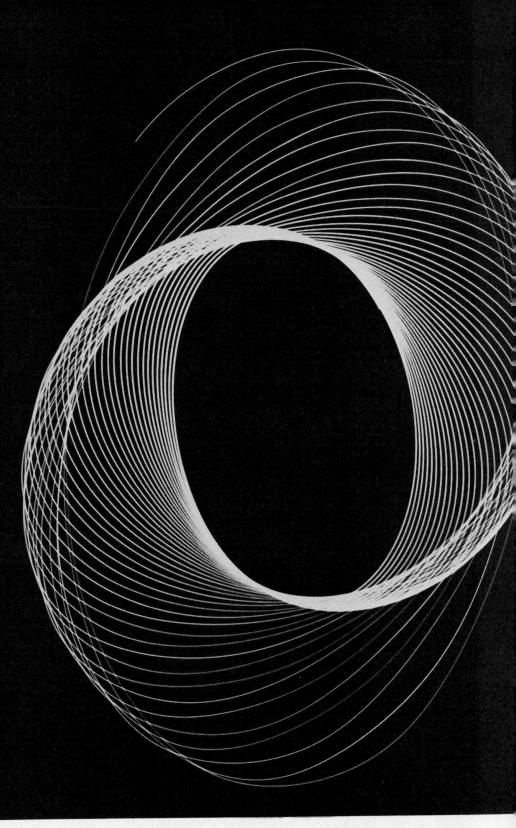

1. While a penlight swung in an oval motion, a time exposure of 40 seconds at f/8 was used to create this physiogram.

2. Sandwiching two negatives together created this physiogram. You can get a similar effect by making a double exposure but getting two patterns that work well on one negative is very difficult.

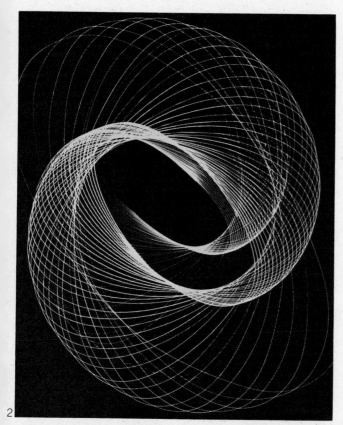

the bulb to create a sharper light source. Since the penlight must hang from its center, you should drill a small hole in the bottom of the case into which you can insert a thin wire or string.

By having the string or wire attached to the center of the penlight, you prevent the light from moving in an irregular pattern. Attach the wire to the ceiling with a U hook. With an eight-foot ceiling, hang the light about five feet from the floor; if it's too low, the swing (and resultant pattern) will have to be greatly restricted to get it all in the picture frame. If the pattern of the swing goes out of the picture frame, then use a wider angle lens, raise the light closer to the ceiling or do not swing the light as hard. If possible, use a waist-level or right-angle finder with an SLR to let you check the pattern and swing. If you have a TLR, this might prove better since you'll be able to watch the light through the viewfinder during the entire exposure.

. The room in which you make your exposures should be totally dark because you're going to have the shutter open for periods of up to several minutes. High-speed film is not necessary; I've found a lens opening of f/5.6 perfect for Ektachrome Pro or Ektachrome-X. If you work with 35mm, use Kodachrome 25 at a lens opening of f/2.8 or f/4. These apertures are suggestions from my experience and should be used only as reference points for your own testing

since the light you use may differ in intensity from mine.

For added effect, try combining several colors in a single exposure. This can be done either by swinging the light and switching colors while making your exposure or by making several different exposures with different swings, using a different color each time you change the swing. Trying to fit colored cellophane over the penlight bulb is the wrong approach; using filters over the lens is better, but if you plan to change filters several times, they become a nuisance.

I've found the best way to change filters easily and quickly is to make a filter board from a 12x15-inch piece of black cardboard. Cut out six square openings of 2¾ inches and tape three-inch Kodak gelatin filters over them. When you want to switch colors, just move the filter board over the lens to the next color. Leave sufficient blank space down the middle of the board so that you can go from any color to another without crossing over into one you don't want to use. Since you're going to be working in total darkness, use glow-in-the-dark tape and outline each opening. You can even code the color of the gel in each opening if you can't remember. The filter density differences are not enough to be concerned with to change the aperture when switching from one to another unless you use very strong gels such as No. 47 blue or No. 61 green, etc.

In addition to altering the

3. Use a low tabletop tripod instead of placing the camera on the floor. If your SLR does not have a replaceable pentaprism, a right-angle viewfinder will work just as well.

4. If you're making physiograms in color, this filter board described in the text makes it easy to switch quickly from one color to another.

way you swing the penlight into motion, there are several ways to get a variety of patterns. One is to attach wires to the main supporting wire to form a V. By altering these two wires connected to the main wire, you can come up with some unique patterns impossible to achieve in any other way. To determine what wire position gives you the patterns you like best requires many carefully marked tests. Make small markings on the ceiling that have corresponding numbers to them. Then as you move the secondary wires to these points, you can make note of it so that when your test shots are processed, you can try duplicating that same design. I say try, since it's practically impossible to get the same one twice.

For other unusual effects, place a texturized glass sheet about two inches below your swinging penlight. If you're shooting multiple exposures on one frame, you might try one that's out of focus. Still another effect, but one that cannot really be considered a physiogram, is to keep the light still and move the camera around during exposure. With a little imagination, you can create endless variations of the penlight effect.

COLORED DYES

Using colored dyes in water is one of the most beautiful ways to make color abstracts, as well as one of the simplest once you've gathered together all the equip- ment and set up the camera and lights. Like penlight patterns, there's no end to the various patterns possible and no two are ever the same.

Here's the basic equipment needed for working with colored dyes in water and the raison d'être for each. To begin with, you should have a small room or working space where you can make the setup without worrying about someone getting in the way. An SLR that will focus close to the subject is the best choice of camera, and you'll need a sturdy tripod. A macro lens is also handy because of its close focusing ability without bellows or extension tubes.

The use of an electronic flash is necessary for two reasons—it produces sufficient light for close-ups of this type and has the action-stopping quality you need. Tungsten lights would have to be extremely bright in order to allow the use of a shutter speed fast enough to stop the movement of the dyes in the water and still have the lens closed down for adequate depth of field. You may use your portable strobe, but a high-power studio unit with 800 watt-seconds or more is perfect, especially if you use a slow film such as Kodachrome 25. My 1250-watt-second unit lets me shoot Kodachrome 25 at f/22 for maximum depth of field.

You'll need a glass fish tank of the type found in pet stores, along with a table to set it on. Behind the tank, you'll want a white back-

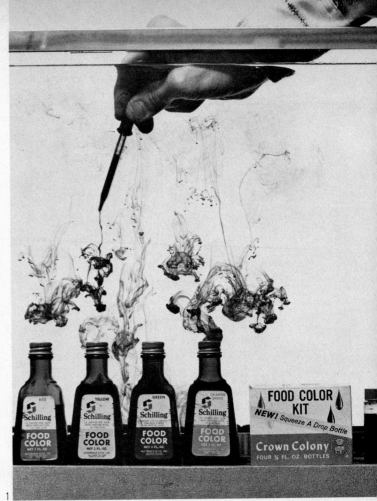

1. Ordinary food coloring released in water makes a variety of interesting and colorful abstractions. Although the dyes come in five basic colors, they can be mixed to produce about every color imaginable. 2. The author's setup for shooting colored dyes in water includes these studio strobes but you can use your own portable electronic flash units instead.

ground. This can be a roll of white paper or a large sheet of white poster board. The size of the background will depend upon how much area you wish to include. If you're using a big fish tank and want to include the entire area, then make sure that the background is sufficiently large to cover it. Your background should also be positioned far enough behind the tank so that it can be lighted evenly.

While a siphon is not an absolute necessity, it does help to drain the water from your tank whenever you want to change it. A large tank full of water is far too heavy to carry and dump, so you have to use a siphon, a beaker or large cup to empty it. If you buy a siphon, choose one that has a large diameter hose to speed the water-changing process.

The final item needed is a set of food coloring dyes. These are sold at any supermarket and come in five basic colors—red, orange, yellow, green and blue—but they can be mixed to produce a variety of other colors. Along with the dyes, you should have an eyedropper for each color. Some dye sets come with eyedroppers, or these can be purchased individually at most drug counters.

After filling your tank with water, wait a few minutes for all the tiny air bubbles to dissipate. Any that cling to the sides of the tank can be removed by touching them with a ruler. To prefocus the lens, place the ruler in the

tank in the general area where you plan to release the dyes and focus on it. This lets you concentrate on the design of the dyes as they travel toward the bottom of the tank, without worrying about having to focus at the same time. There are two ways in which you can release the colored dyes into the water and each produces a different effect.

Hold an eyedropper containing dye one inch to one foot over the water and release a drop or two. As soon as the dye hits the water, it will start to disperse and become less concentrated as it travels toward the bottom of the tank. During this time, it takes on different forms as it spreads out. The higher above the water the eyedropper is held, the quicker the dye disperses. So you can control the dye patterns to some extent by altering the distance the eyedropper is held above the water. You can also change the result by letting several drops of dye into the water at the same time or releasing dye from several different droppers, each a different color. The other way to release the dye is to place the eyedropper into the water and simply let it ooze out slowly. There's no end to the variety of abstractions the dyes will form as they move through the water.

You may want to try for different effects, such as mixing the dye with other substances. If you use milk mixed with the dye, you get an opaque effect. You might

also try mixing egg whites with the dyes. This forms different patterns than the dyes do by themselves. To this point, you have been photographing a white background but you can make it any color desired by using filters meant for black-and-white film (A, X1, K2, etc.) over the lens. When using strong colored filters, it's best to use a dye that's very dark in color to have enough contrast and separation between the colors so you can see the dye pattern easily.

OUT-OF-FOCUS HIGHLIGHTS

Those photographers who believe that everything should be tack-sharp have overlooked the beauty of out-of-focus highlights. There are few things that look more beautiful in a picture than bright highlights that are out of focus; they seem to have a dreamy and poetic quality about them. These work so well because they are small, concentrated points of light that become larger and softer as they are thrown out of focus.

There are four basic ways of creating out-of-focus highlights: spotlights shining on aluminum foil, spotlights shining on glitter, water highlights caused by the sun's rays and point source lights at night or in a darkened room. Crumpling up a roll of aluminum foil is one of the easiest. Buy the widest roll you can find, wrinkle up a three- to four-foot piece and then straighten it out somewhat. Now direct a spotlight

on the foil and you'll get a multitude of highlights reflecting back. Place your camera on a tripod and aim it at the foil, but adjust the lens focus until these highlights are out-of-focus. Incidentally, a rangefinder camera is not very well suited for this technique—you need an SLR to really see the exact effect you'll get.

Remember to set your lens at its widest aperture or you won't get complete circles in your out-of-focus highlights. If you stop the lens down to about f/5.6 or f/8, you'll get a hexagon shape that's similar to the shape of the lens diaphragm. Actually, you can make the circles into any shape you want by using a disk over the lens that has the particular shape desired cut out. To make such a disk, cut a piece of thin black cardboard to fit your adapter ring, then cut out the center to whatever shape you want the highlights to take. With this mask over the lens, you usually lose about two f-stops in exposure. It's best to keep the cutout fairly simple (without much detail) or it may not show up in the picture.

Aluminum foil produces out-of-focus highlights that stack up together, with many of them overlapping. To get a different effect with more space between groups of circles, try using glitter against a black velvet background. This is available from most stores that handle yard goods, many 5 & 10¢ stores, or you can buy it from one that sells costumes

for dancers. Since glitter comes in many colors and in various sizes, you'll have a good variety to choose from.

Another interesting source of highlights is bright sunlight reflecting off of water. Highlights from water show up best when the angle of the sun is such that its light will hit the water and bounce into your lens. This usually happens in the early morning or late afternoon when the sun is closer to the horizon. The exception to this rule is when you're on a high cliff shooting almost straight down. There must also be enough wind to create ripples in the water that will pick up the sunlight and reflect it. When shooting water highlights, try several shots using a model in the foreground in focus to add more interest to the picture.

Point source lights like those found on Christmas trees, used car lots, airport runways, etc. are another means of obtaining the out-of-focus highlight effect. These lights also work very well with the disk cutout if you want to produce shapes other than just circles. Try multiple exposures using different disks and move the camera slightly between exposures. If you're shooting color, try using a different filter for each exposure.

Changing focus during exposure is another interesting technique—you simply rack the lens out of focus during the last part of the exposure. You record the scene in focus but the highlights flare out into big circles, giving

the best of both worlds—abstraction and reality.

REFLECTIONS

Considering reflections, there are many that are very interesting but not completely abstract in nature. But by using refections, you can add an element of abstraction to an otherwise normal photograph and make it a much better picture. Most photographers think in terms of how to eliminate reflections, and so to overcome this, you must train and discipline your eye to look for them. Otherwise, they can be right in front of you and you'll pass them right by. To build an awareness of reflections, think about them constantly and always look for them. After a while, your mind will be trained to look for them whenever you're out shooting.

A reflection can be no more than the application of a simple technique, or it can be used to make a statement by having it relate to the subject. For example, a girl on the beach reflected in a pair of sunglasses worn by a grinning man; used in this manner, each relates to the other to tell more of a story. There are several types of reflections to be concerned with here: water reflections, window reflections, mirror reflections, reflections from chrome and high-gloss paint and commonplace objects such as sunglasses, silver platters, teapots, etc.

Water reflections cover everything from a small puddle to a huge lake. We can split

Another interesting technique is to photograph sequins against a black background adding a cross-star filter to the lens as in photo top. In photo top right a different way of creating out-of-focus highlights is shown. Try sprinkling some glitter on a black background, rack the lens completely out of focus, and shoot. Cut a simple mask from thin black cardboard as shown above and fit it to an adapter ring to change round out-of-focus highlights to different shapes—you can even create snowflake designs as shown below right.

them into two types: the mirrorlike, in which you can see detail as in a very quiet lake, and the type where the reflection is almost completely abstract, such as a close-up of wet pavement at night, or water that's in motion. If you want to photograph the mirror type, wait for a day when there's very little wind. Morning is very good, since the body of water or lake is more likely to be calm, and just before the sun comes over the horizon, the lighting is very soft and creates a beautiful effect. Or, if you're shooting toward the sun, you can get a very graphic and bold silhouette. Silhouettes are also useful when the water is partially in motion, since detail in the reflection is unnecessary for it to read. As a rule, it's best when more light is shining on the subject than on the water.

You'll find the darker the pool of water, the more it will reflect, and fortunately, most lakes are deep enough so that they have a fairly dark bottom. If you ever have to take pictures in a swimming pool, line the bottom with large pieces of black plastic, since that's the only way to get a good reflection. Water does not always have to be completely still; in fact, a little ripple sometimes makes the picture more interesting. You can photograph the subject and reflection, or just the reflection by itself.

Wet pavement or sand gives another type of reflection worth considering as subject matter. Usually,

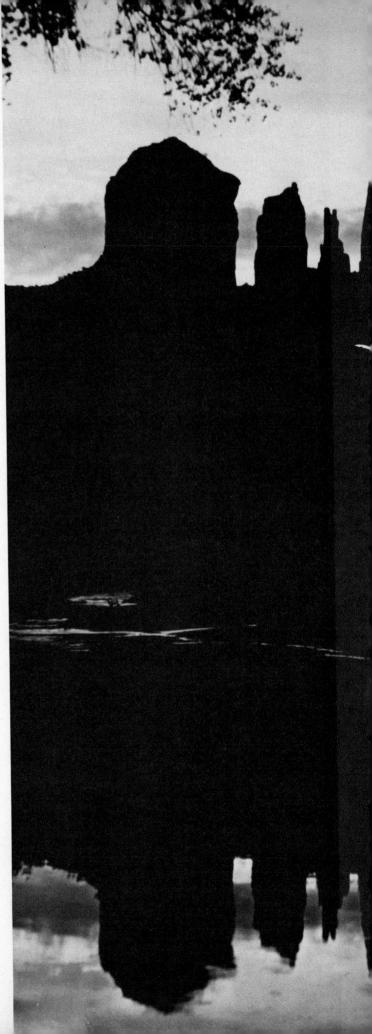

there's not much detail in this type of reflection, but it can prove to be very colorful. Shoot the wet pavement reflections of neon signs and street lights some evening after it has just rained. To add impact if the lighting does not have enough brilliant color in it, use different colored filters over the lens.

Window and building reflections have great potential for the creative among you. With one kind, you get a reflection of the sky or sun that will turn a glass-window building into a blazing golden color. This type is very dramatic but to capture it on film the sun must be bright enough at sundown to reflect off the windows into your lens. By keying your exposure to this high-intensity reflection from the windows, everything else in the picture will go very dark.

The other type of window reflection is one in which you see a partial reflection with the remainder transparent—you can see into the window and at the same time, see the image that is reflected on the window—perhaps a young girl looking out of the window with a reflection of a boy walking by. This offers considerable potential because you're able to show two images without having to double-expose or sandwich. It's also a real situation and completely believable. To make reflection pictures of this type, you must plan ahead and set up in advance, since trying to capture them spontaneously can be most frustrating.

The mirror is probably the most often used surface for shooting reflections. The first is the type you find already set up and in place—at a department store, on the wall at home or even at amusement parks. When shooting mirror reflections, it's best to use a model in your picture. To get more interesting effects, try using three-sided mirrors such as those found in clothing stores.

After you've taken a number of mirror shots, you may want to go to some extra trouble and set up your own. This is the second type, in which you have control over the final result. If you can afford a mirror that measures 4x6 feet, you can take some unique shots with it. For example, place this mirror on the floor against a plain background and have your model kneel, sit or lie down on it. You get a very interesting double image you're not likely to see very often. By using backlighting and having your model assume a silhouette pose with arms and legs separated, you can create a very graphic abstract. You can also place the mirror on a table with your model sitting at the end of it and produce another type of double image.

If you really catch the mirror-reflection fever, use a pair of 4x6-foot mirrors and position them so they face each other to create a long row of reflecting images. Smaller ones can also be used for many effects. All types of tabletop shots can be enhanced by using mir-

rors, especially those of glassware. High backlighting with a soft fill works best when doing tabletop mirror shots. An interesting effect can be achieved by placing a small front-surface mirror underneath your lens for still another type of double image—use a wide-angle lens stopped all the way down for maximum depth of field.

Curved chrome reflections contain a strong distortion factor but produce a good amount of detail. Objects such as toasters, tubas and chrome strips on cars all make excellent subjects for reflections. Darkroom ferrotype plates are another excellent reflective surface and you can take one anywhere with you. By asking another person to hold it, you can also control the degree of distortion. In addition to chrome, look for reflections from other highly polished metals, as well as high gloss paint, especially black. Black plastic will also produce good results.

Such simple things as a pair of sunglasses, a silver platter or even highly polished silverware can sometimes work. Even drinking glasses will show a reflection if there's lots of light on the subject and the glass is filled with a dark liquid. Once you start training your mind to think in terms of using reflections (instead of how to eliminate them), you'll be surprised at how many objects have reflective qualities you've never noticed before.

And so this brings us to the fade-out—also a special effect if you're shooting movies. Now it's time for you to load up your camera and try your hand at creating your own world of special effects. Once you've tried a few of the many techniques we've covered here, you'll be well on your way to a new appreciation and enjoyment of your hobby. ☐

Shooting reflections in water can produce very effective pictures. Look for a lake or pond where the water is very still. Bold subjects such as backlighted mountains at left are ideal. Reflections from small objects like the sunglasses above can make interesting pictures. Stop the lens down for greater depth of field to include both foreground and the reflected image.

MANUFACTURERS AND DISTRIBUTORS

Aetna Optix
44 Alabama Ave., Box 268
Island Park, Long Island
N.Y. 11558
Filters and prisms

AIC Photo Inc.
168 Glen Cove Rd.
Carle Pl., N.Y. 11514
Auxiliary lenses,
filters and prisms

American St. Gobain Corp.
Box 929
Kingsport, Tenn. 37662
Pattern glass

Arkay Corp.
228 South First St.
Milwaukee, Wisc. 53204
Optical devices

Berkey Colortran
1015 Chestnut St.
Burbank, Calif. 91502
Filters and colored gels

Saul Bower, Inc.
114 Liberty St.
New York, N.Y. 10006
Auxiliary lenses

Braun North America
55 Cambridge Parkway
Cambridge, Mass. 02142
Auxiliary lenses

Camera Service Center
4355 South Sepulveda Blvd.
Culver City, Calif. 90230
Camera service

Diversy Creation Corp.
Box 8167
Wichita, Kan. 67208
Special effects kits

Dot Line Corp.
11916 Valerio St.
North Hollywood,
Calif. 91605
Filters and prisms,
panoramic cameras

Eastman Kodak Company
Rochester, N.Y. 14650
Special purpose films,
bulbs and chemicals

Edmund Scientific
300 Edscorp Building
Barrington, N.Y. 08007
Filters and prisms,
optical devices,
diffraction gratings,
special effects kits

Ednalite Corp.
210 North Water St.
Peekskill, N.Y. 10566
Filters and prisms

Freestyle Photo Sales
Box 27924
Hollywood, Calif. 90027
Special purpose films,
bulbs and chemicals

Harrison & Harrison
6363 Santa Monica Blvd.
Hollywood, Calif. 90038
Filters and prisms

Harrison Camera Corp.
249 Post Ave.
Woodbury, Long Island
N.Y. 11590
Panoramic cameras

Imex Imports
Box 494
Silverado, Calif. 92676
Panoramic cameras

Kalimar, Inc.
2644 Michigan Ave.
St. Louis, Mo. 63118
Auxiliary lenses,
optical devices,
panoramic cameras,
filters and prisms

Kalt. Corp.
2036 Broadway
Santa Monica, Calif. 90404
Auxiliary lenses,
filters and prisms

Larson Enterprises, Inc.
18170 Euclid St.
Fountain Valley
Calif. 92708
Reflectors

Paterson:
see Braun North America.

Pictorial Company
Rt. 2, Box 72
Deming, N.H. 88030
Anamorphic lenses

Ponder & Best, Inc.
1630 Stewart St.
Santa Monica
Calif. 90406
Filters and prisms

P.R.O.
171 Madison Ave.
New York, N.Y. 10016
Anamorphic lenses,
filters and prisms

Reflectasol:
see Larson Enterprises.

Samigon Corp.
111 Asia Pl.
Carlstadt, N.J. 07072
Anamorphic lenses,
filters and prisms

Spiratone, Inc.
135-06 Northern Blvd.
Flushing, N.Y. 11354
Anamorphic lenses,
filters and prisms,
texture screens

Texturefects
7557 Sunset Blvd.
Hollywood, Calif. 90028
Texture screens

Tiffen Optical Company
71 Jane St.
Roslyn Heights
N.Y. 11577
Filters and prisms

Uniphot, Inc.
61-10 34th Ave.
Woodside, N.Y. 11377
Anamorphic lenses

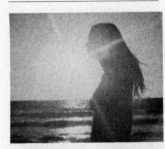

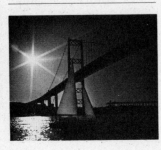

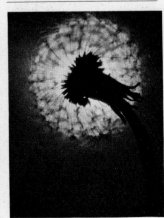